Orphans

by Dennis Kelly

First performed on 31 July 2009
at the Traverse Theatre, Edinburgh

Cast

Liam Joe Armstrong
Helen Claire-Louise Cordwell
Danny Jonathan McGuinness

Director Roxana Silbert
Designer Garance Marneur
Lighting Designer Chahine Yavroyan
Sound Designer Matt McKenzie
Assistant Director Ben Webb

Stage Manager Paul Southern
Deputy Stage Manager Martin Hinkins
Assistant Stage Manager Naomi Stalker

Company Biographies

Joe Armstrong (*Liam*)

Joe's theatre credits include *A Night At The Dogs*, *Protection* (Soho Theatre); *How Love Is Spelt* (Bush Theatre). Television credits include three series of *Robin Hood* (BBC). Other television credits include *Whistleblowers*, *Party Animals*, *Inspector Lynley*, *Coming Up 2005*, *Rose & Maloney*, *Midsomer Murders*, *Foyles War*, *Blackpool*, *Waking the Dead*, *Passer By*, *Between the Sheets*, *The Bill*.

Claire-Louise Cordwell (*Helen*)

Claire-Louise trained at RADA and graduated in 2004. Theatre credits include *The Frontline* (Shakespeare's Globe); *Torn* (Arcola); *Othello* (Frantic Assembly); *Dirty Butterfly* (Young Vic); *Days of Significance* (RSC); *Burn, Citizenship* (National Theatre); *Stoning Mary* (Royal Court Theatre); *Compact Failure* (Clean Break Theatre Company). Television credits include *The Day of the Triffids*, *Law & Order*, *Eastenders*, *The Bill*, *Trail and Retribution*, *Doctors*, *Casualty*, *Bad Girls*, *Jane Hall*. Film credits include: *Stuart: A Life Backward*. Short film credits include: *The Curry Club*, *Freshments*. Radio credits include: *Lacy's War* (BBC*)*; *The Tudors*.

Dennis Kelly (Writer)

Plays include *Debris* (Theatre 503, BAC, 2003), *Osama the Hero* (Hampstead Theatre, 2005), *After the End* (Paines Plough, Traverse, The Bush, UK and international tour, 2005), *Love and Money* (Young Vic, Royal Exchange, 2006) and *Taking Care of Baby* (Hampstead Theatre, Birmingham Repertory Theatre, 2007). Plays for young people are *DNA* (The National Theatre, 2008) and *Our Teacher is a Troll* (National Theatre of Scotland, 2009).

Garance Marneur (Designer)

Garance studied fine art in Paris and went on to graduate in Design for Performance from Central Saint Martins in London. She designs set and costume for Theatre, Dance and Opera including most recently *I Am Falling* at the Gate Theatre and Sadler's Wells (nominated for a South Bank Show Award); *Dirty Butterfly* at the Young Vic, *Gianni Schicchi* conducted by Valery Gergiev at the Mariinsky Theatre (Opera- St Petersburg), *Romeo and Juliet* at the National Theatre Studio, *Turandot* (winning design of the Linbury Prize for Stage Design) at the Hampstead Theatre and *Gagarin Way* for Theatre Royal Bath. Future projects include *Romeo and Juliet* at StadtTheatre Bern (Ballet-Switzerland) and a tour of HUCK. Garance Marneur was the 2007 recipient of the prestigious Linbury Biennial Prize for Stage Design.

Jonathan McGuinness (*Danny*)

Jonathan's theatre credits include *Love, Metamorphosis* (Vesturport/Lyric Theatre); *Comfort Me With Apples* (Hampstead Theatre); *Once In A Lifetime*, *Playing with Fire*, *The UN Inspector* (National Theatre); *Pyrenees* (Paines Plough/Tron Theatre); *Jeff Koons* (ATC); *A Midsummer's Night Dream*, *Rose Rage*, *Twelfth Night*, *Comedy of Errors*, *Henry V* (Propeller/Watermill); *Richard III*, *Mojo* (Crucible Theatre); *Last Valentine* (Almeida Theatre); *Crazy Horse* (Paines Plough). Televison credits include three series of the *Catherine Tate Show* (BBC). Other television credits include *Casualty*, *Doctors*, *Robin Hood*, *Touch of Frost*, *In The Search Of The Brontes*, *The Convicts*, *Have Your Cake and Eat It*, *Coogans Run* and *Sharpe's Gold*.

Matt McKenzie (Sound Designer)

Matt came to the UK from New Zealand in 1978. He toured with Paines Plough before joining the Lyric Theatre Hammersmith in 1979, and then Autograph Sound in 1984. Theatre work includes: *Wuthering Heights* (Birmingham Repertory Theatre); *Flamingos, Damages, After The End, tHedYsFUnCKshOnalZ* (Bush Theatre); *The Seagull, Master and Margarita, 5/11, Babes In Arms, Funny*

Girl, Music Man, Oklahoma! (Chichester Festival Theatre); *Frame312, After Miss Julie* and *Days of Wine and Roses* (The Donmar); *Sweeney Todd, Merrily We Roll Along* (Derby Playhouse); *The Giant* (Hampstead); *Three Sisters on Hope Street* (Liverpool Everyman); *Angry Housewives, The Way of the World, Ghost Train* (Lyric Theatre Hammersmith); *Family Reunion, Henry V, Hamlet, The Lieutenant of Inishmore, Julius Caesar, A Midsummer Night's Dream, Indian Boy* (RSC); *Leaves of Glass, Baghdad Wedding* (Soho); *Iron, The People Next Door* (Traverse Theatre); *Made in Bangkok, The House of Bernarda Alba, A Piece of My Mind, Journey's End, A Madhouse in Goa, Gasping, Tango Argentino, When She Danced, Misery, Things We Do For Love, Long Day's Journey Into Night, Macbeth, Sexual Perversity in Chicago, A Life in the Theatre, Nicholas Nickleby, Female of the Species* (West End); *Amadeus, Lysistrata, The Master Builder, School for Wives, A Streetcar Named Desire* (for Sir Peter Hall). Matt was also Sound Supervisor for the Peter Hall Seasons at The Old Vic and The Piccadilly and designed the sound for *Waste, Cloud 9, The Seagull, The Provok'd Wife, King Lear, The Misanthrope, Major Barbara, Filumena, Kafka's Dick*.

Roxana Silbert (Director)

Roxana is Artistic Director of Paines Plough and Associate Director at the RSC. She was Literary Director at the Traverse Theatre (2001-2004) and Associate Director, Royal Court (1998-2000). In 1997, Roxana was Associate Director of West Yorkshire Playhouse where she directed *Precious* by Anna Reynolds. For Paines Plough: *Roaring Trade* (Soho Theatre); *Dallas Sweetman* (Canterbury Cathedral); *Shoot/Get Treasure/Repeat* (Village Underground/North Wall/Latitude); *Long Time Dead* (Plymouth Theatre Royal/Traverse Theatre); *After The End* (Traverse, The Bush, 59e59, international tour); *Strawberries in January* (Traverse); *Being Norwegian, Between Wolf and Dog* (Shunt Vaults/Òran Mór); *Under my Skin* (Òran Mór). For the Traverse: *The Slab Boys, Still*

Life, The People Next Door, 15 Seconds, Iron, Green Field, Quartz. For the Royal Court: *At the Table/Still Nothing, I Was So Lucky, Been So Long, Fairgame, Bazaar, Sweetheart, Mules*. Other recent theatre includes: *Under The Black Flag* (Globe); *Whistle in the Dark* (Citizens Theatre, Glasgow); *Blond Bombshells* (West Yorkshire Playhouse); *Property* (RNT Studio); *Damages* (Bush Theatre); *Brixton Stories* (RSC); *Fast Show Live* (Hammersmith Apollo/tour); *Splash Hatch on the E Going Down* (Donmar Warehouse); *The Treatment* (Intercity Theatre, Festival, Florence). *Orphans* is Roxana's last show as Artistic Director of Paines Plough.

Chahine Yavroyan (Lighting Designer)

Previous work with Paines Plough includes *Dallas Sweetman, House of Agnes, Long Time Dead, After the End*. Recent theatre work includes: *Fuente Ovejuna* (Teatros del Canal, Madrid); *Three Sisters* (Manchester Royal Exchange); *Relocated* (Royal Court Upstairs), *Wig Out!* (Royal Court Downstairs); *Ghost Sonata* (The People Show); *Fall, Damascus, When the Bulbul Stopped Singing* (Traverse Theatre); *Have Box Will Travel* (The Door, Birmingham Repertory Theatre); *The Wonderful World of Dissocia, Realism* (National Theatre of Scotland); *Mahabharata* (Sadler's Wells); *God in Ruins* (RSC at Soho Theatre); *Il Tempo del Postino* (Manchester International Festival); *There's Only One Waine Matthews* (Polka Theatre); *Ornamental Happiness* (Unity Theatre); *How to Live* (Barbican Theatre); *Othello* (Nottingham Playhouse).

Dance work with: Jasmin Vardimon, Candoco, Frauke Requardt Dance, Bock & Vincenzi. Site-specific work includes: *Il Tappeto Dei Sogni* (Polverigi, Italy); *Enchanted Parks, Dreams of a Winter Night, Deep End and Spa for Corridor, Light Touch* (Scarabeus). Music work includes: *Diamanda Galas* (Spain); *Dalston Songs* (ROH2); *Plague Songs* (Barbican Hall).

The Traverse

Artistic Director Dominic Hill

The importance of the Traverse is difficult to overestimate . . . without the theatre, it is difficult to imagine Scottish playwriting at all. (Sunday Times)

The Traverse's commissioning process embraces a spirit of innovation and risk-taking that has launched the careers of many of Scotland's best-known writers including John Byrne, David Greig, David Harrower and Liz Lochhead. It is unique in Scotland in that it fulfils the crucial role of providing the infrastructure, professional support and expertise to ensure the development of a dynamic theatre culture for Scotland.

The Traverse Theatre, the festival's most prestigious home of serious drama. (New York Times)

From its conception in the 1960s, the Traverse has remained a pivotal venue in Edinburgh. It receives enormous critical and audience acclaim for its programming, as well as regularly winning awards. In 2009, *Pornography* by Simon Stephens was awarded Best New Play at the Critics Awards for Theatre in Scotland making it the second consecutive win for a Traverse production with Alan Wilkins' *Carthage Must Be Destroyed* picking up the award in 2008. From 2001–07, Traverse productions of *Gagarin Way* by Gregory Burke, *Outlying Islands* by David Greig, *Iron* by Rona Munro, *The People Next Door* by Henry Adam, *Shimmer* by Linda McLean, *When the Bulbul Stopped Singing* by Raja Shehadeh, *East Coast Chicken Supper* by Martin J Taylor, *Strawberries in January* by Evelyne de la Chenelière in a version by Rona Munro and *Damascus* by David Greig have won Fringe First or Herald Angel awards (and occasionally both). In 2008 the Traverse's Festival programme Manifesto picked up an incredible sixteen awards including a record seven Scotsman Fringe Firsts and four Herald Angels.

A Rolls-Royce machine for promoting new Scottish drama across Europe and beyond. (The Scotsman)

The Traverse's success isn't limited to the Edinburgh stage. Since 2001 Traverse productions of *Damascus, Gagarin Way, Outlying Islands, Iron, The People Next Door, When the Bulbul Stopped Singing,* the *Slab Boys Trilogy, Mr Placebo* and *Helmet* have toured not only within Scotland and the UK, but in Sweden, Norway, the Balkans, the Middle East, Germany, USA, Iran, Jordan and Canada. In 2009 the Traverse toured its production of *Midsummer* by David Greig and Gordon McIntyre to Ireland and Canada.

Discover more about the Traverse at www.traverse.co.uk

Traverse Sponsorship and Development

Traverse Theatre – The Company

Katy Brignall	Assistant Box Office Manager
Maureen Deacon	Finance Assistant
Steven Dickson	Head Chef
Neil Donachie	Bar Café Duty Manager
Martin Duffield	Box Office & IT Manager
Claire Elliot	Deputy Electrician
Margaret Fowler	Finance Manager
Craig Fyfe	Second Chef
Mike Griffiths	Administrative Director
Gavin Harding	Production Manager
Zinnie Harris	SAC Senior Playwriting Fellow
Dominic Hill	Artistic Director
Sam Holcroft	Pearson Playwright
Sarah Holland	Wardrobe Supervisor
Jules Horne	Young Writers Group Leader
Aimee Johnstone	Bar Café Assistant Manager
Kath Lowe	Front of House Manager
Cheryl Martin	SAC Director in Residency
Ruth McEwan	Administrative Assistant
JJ McGregor	Head of Stage
Katherine Mendelsohn	Literary Manager
Sarah Murray	Programme Administrator
Noelle O'Donoghue	Head of Traverse Learning
Gwen Orr	Theatre Manager
Emma Pirie	Press & Marketing Officer
Pauleen Rafferty	Finance & Personnel Assistant
Renny Robertson	Chief Electrician
Claire Ross	Marketing & Press Officer
Steven Simpson	Executive Bar Café Manager
Mark Sodergren	Head of Sound & AV
Louise Stephens	Literary Officer
Fiona Sturgeon Shea	Head of Communications

Also working for the Traverse: Peter Airlie, Gillian Argo, Richard Bell, Beata Brignall, Peter Boyd, Koralia Daskalaki, Ruari Dunn, Kelly Enderwick, Alison Fraser, Andrew Gannon, Bridget George, Linda Gunn, Nikki Hill, Tessa Kelly, Rebecca King, Elin Kleist, Terry Leddy, Kate Leiper, Dan Mackie, Graeme Mackie, Catherine Makin, Jean-Marc Maledon, Heather Marshall, Helen McIntosh, John Mitchell, Grant Neave, Michael Osborne, Matthew Ozga-Lawn, Clare Padgett, Aidan Paterson, Laura Penny, Tim Primrose, Emma Robertson, Sarah Scarlett, Greg Sinclair, Adam Siviter, Gulli Skatun, Bryony Smith, Sally Smith, Nina Spencer, David Taylor, Emma Taylor, Kate Temple, James Turner Inman, Anna Walsh, Jenna Watt, Marie Williamson, Katie Wilson.

THE REP

Birmingham Repertory Theatre

Founded in 1913 Birmingham Repertory Theatre is one of Britain's leading national theatre companies. From its base in Birmingham, The REP produces over twenty new productions each year, some of which tour nationally and internationally. Under the Artistic Direction of Rachel Kavanaugh, The REP is enjoying great success with a busy and exciting programme.

Rachel Kavanaugh has just announced her season of work for Autumn & Winter 2009. The season includes this world premiere of *Orphans* by Dennis Kelly as well as the world premiere of *Cling To Me Like Ivy* by Samantha Ellis, alongside new productions of Ayub Khan Din's *East Is East* and *A Christmas Carol* adapted by Bryony Lavery.

The REP's productions regularly transfer to London and tour nationally and internationally. Forthcoming tours include Simon Stephen's *Pornography* and Samantha Ellis' *Cling To Me Like Ivy*. Recent West End transfers and tours have included *His Dark Materials, Brief Encounter, Looking For Yoghurt, She Stoops To Conquer, Taking Care Of Baby, Glorious!, The Birthday Party, The Witches, Of Mice And Men, A Doll's House, The Crucible, Celestina, Hamlet, The Ugly Eagle, The Old Masters, The Snowman,* and *The Ramayana*. In 2009 The REP's production of *The Snowman* made its international debut in Seoul, Korea and later this year will tour to the Netherlands, Germany, Spain and the Czech Republic

The commissioning and production of new work lies at the core of The REP's programme. The Door was established in 1998 as a theatre dedicated to the production and presentation of new writing. In this time, it has given world premieres to new plays from a new generation of British playwrights.

Developing new and particularly younger audiences is also at the heart of The REP's work, in its various Education initiatives, such as Transmissions, The Young REP and REP's Children, as well as with the programming of work in The Door for children.

Artistic Director Rachel Kavanaugh
Executive Director Stuart Rogers

Box Office: 0121 236 4455
Stage Door: 0121 245 2000
birmingham-rep.co.uk

Birmingham Repertory Theatre is a registered charity, number 223660

Birmingham Repertory Theatre's new writing policy

The commissioning and production of new work lies at the core of The REP's programme. In 1998 the company launched The Door, a venue exclusively dedicated to the production and presentation of new work. In this time, it has given world premieres to new plays from a new generation of British playwrights. The Door aimed to provide a distinct alternative to the work seen in the Main House: a space where new voices and contemporary stories could be heard, that sought to create new audiences for the work of the company in this city and beyond. The Door has also been a place to explore new ideas and different approaches to making theatre, to develop new plays and support emerging companies and artists.

The new Library of Birmingham project has enabled us to rethink our new writing policy and with the intended third space, The Door will no longer be the only venue for the development and production of new work. This brings with it more opportunities to develop new work and to consolidate the new work that already happens outside of The Door. The diversity of work includes early years' work, new plays for the Young REP, the theatre's resident youth theatre, adaptations, responding to specific briefs, community plays, writer/performer, collaborative writing, site specific work and incorporating digital technology into the development and production of work. We will shortly be launching a core new writing programme that supports the generation of such material in addition to enabling writers and artists the chance to explore new ways of working.

Transmissions, The REP's young writers' programme has worked with hundreds of writers aged 12 – 25 across the region and the next phase of this work is to help establish playwriting into the national curriculum. One new programme of work will focus on young artists aged 18 – 30 and enable writers to explore different ways of telling stories from playwriting to spoken word to grime theatre. Our priority will also be to begin to develop new work that is suitable for the new space, and expands our repertoire of work by the addition of this middle scale space.

In collaboration with the BME Theatre Initiative, we aim to constantly explore the role of the writer and the form of telling stories in theatre.

Birmingham Repertory Theatre Company

Duty Managers
Darren Perry
Nicola Potocka

Sales Manager
Gerard Swift

Sales Team Supervisor
Rebecca Thorndyke

Sales Development Supervisor
Rachel Foster

Sales Team
Anne Bower
Kayleigh Cottam
Sebastian Maynard-Frances
Eileen Minnock
Jonathan Smith
Ryan Wootton

Senior Usher
Brenda Bradley

Thanks to our team of casual Box Office
staff, ushers and firemen

Stage Door Reception
Tracey Dolby
Robert Flynn
Neil Hill
Julie Plumb

Building Services Officer
Colin Williamson

Building Services Assistant
John Usowicz

Cleaning by ISS Servisystem Midlands

Head Of Production
Tomas Wright

Production Manager
Milorad Zakula

Production Assistant
Hayley Seddon

Head Of Stage
Adrian Bradley

Deputy Head Of Stage
Kevin Smith

Stage Technicians
Guy Daisley
Mario Fortuin

Head Of Lighting
Andrew Fidgeon

Deputy Head Of Lighting
Phil Swoffer

Lighting Technicians
Anthony Aston
Simon Bond

Head Of Sound
Dan Hoole

Deputy Head Of Sound
Clive Meldrum

Company Stage Manager
Ruth Morgan

Workshop Supervisor
Margaret Rees

Construction Coordinator
Oliver Shapley

**Carpenters/Metalworkers/
Propmakers**
Anthony Cowie
Alex Walshaw

Head Scenic Artist
Christopher Tait

Properties And Armourer
Alan Bennett

Head Of Wardrobe
Sue Nightingale

Wardrobe Assistants
Lara Bradbeer
Melanie Francis
Brenda Huxtable
Debbie Williams

Head of Wigs and Make-up
Andrew Whiteoak

With thanks to the following volunteers
Student REPresentatives

REP Archivist
Horace Gillis

paines**PLOUGH**

Paines Plough is an award-winning, nationally and internationally renowned theatre company, specialising exclusively in commissioning and producing new plays.

Some of the most exciting theatre in the UK. (The Guardian)

Paines Plough celebrates the writer's place at the heart of theatre. We value playwrights with an original voice, a unique sensibility and a passion for engaging with the contemporary world. We collaborate with playwrights at every stage of their careers. We encourage and support the very best emerging talent, as well as working alongside some of the most established and influential playwrights writing today.

Inspired by the creativity of our writers, we seek out the most exciting spaces in which to produce our work. Recent productions have been seen in the nave of Canterbury Cathedral and in the heart of the West End; lunchtimes in Glasgow, tea times in Lambeth, late night in Trafalgar Studios; in the best regional theatres, in fields, warehouses, railway arches, and converted swimming pools; in Berlin, Moscow and at the Edinburgh Festival.

... Paines Plough's nomadic theatre company has racked up so many stars that browsing its press release is a bit like looking into deep space. (Metro)

We strive to keep theatre affordable and inspiring to our existing audience while making theatre going accessible and stimulating to new audiences.

Paines Plough is:

Artistic Director	**Roxana Silbert**
General Manager	**Anneliese Davidsen**
Literary Director	**Tessa Walker**
Administrative Assistant	**Clare Martynski**
Book-Keeper	**Wojtek Trzcinski**
Senior Reader	**Jane Fallowfield**

Bola Agbaje	Pearson Playwright in Residence
Phil Davies	Rod Hall Memorial Award Winner 2008

Press **Clióna Roberts 07754 756 504**

Paines Plough Board of Directors: **Ola Animashawun, Christopher Bath, Tamara Cizeika, David Edwards (Chair), Chris Elwell (Vice Chair), Fraser Grant, Marilyn Imrie, Clare O'Brien, Jenny Sealey MBE, Simon Stephens**

To find out more or to join our mailing list visit www.painesplough.com

Paines Plough has the support of the Pearson Playwrights' scheme sponsored by Pearson plc and of Channel 4 for Future Perfect.

ORPHANS

methuen | drama

LONDON • NEW YORK • OXFORD • NEW DELHI • SYDNEY

METHUEN DRAMA
Bloomsbury Publishing Plc
50 Bedford Square, London, WC1B 3DP, UK
1385 Broadway, New York, NY 10018, USA
29 Earlsfort Terrace, Dublin 2, Ireland

BLOOMSBURY, METHUEN DRAMA and the Methuen Drama logo are
trademarks of Bloomsbury Publishing Plc

First published in Great Britain by Oberon Books 2009
Reprinted 2010 (twice), 2011
This edition published by Methuen Drama 2022

A catalogue record for this book is available from the British Library.

A catalog record for this book is available from the Library of Congress.

ISBN: PB: 978-1-3502-6592-9
eBook: 978-1-8494-3953-4

Printed and bound in Great Britain

To find out more about our authors and books visit www.bloomsbury.com
and sign up for our newsletters.

Characters

HELEN

DANNY

LIAM

I'd like to thank Matthew Dunster, David Lan, Tessa Walker, Ben Payne and Mel Kenyon for their help with this script. But most of all I'd like to thank Rox, for once again being tough as fuck and not letting me get away with anything.

ONE

HELEN and DANNY's flat.

A candlelit dinner, interrupted.

HELEN dressed up, DANNY dressed up.

LIAM stands there having just come in.

He has blood all down his front.

Pause. They stare at him.

For a long time.

LIAM Alright, Danny?

DANNY Liam.

LIAM Helen.

HELEN Liam.

 Pause.

LIAM How's it –

 How's it going, like, you alright?

DANNY What? Yeah.

 Pause.

 You?

LIAM Yeah. You know.

 Beat.

 Not too, er…

 You know.

DANNY Right.

 Pause.

LIAM Nice dress.

HELEN What?

LIAM Nice

 dress.

> *Beat.*

 Is it new?

HELEN Is it new?

LIAM Yeah, is it, like

HELEN Is my dress new?

LIAM Yeah, is it –

HELEN Yes. It's new, Liam.

 It's a new dress.

LIAM It's nice, it's sort of –

 It's one of those…

> *Beat.*

 You having dinner? Where's Shane?

DANNY He's at my mum's.

LIAM Right. Nice. So you're having like a

DANNY Yes.

LIAM what, like celebratory, celebrating

DANNY What?

LIAM like a romantic

DANNY Yeah.

LIAM What's that, salmon?

HELEN You're covered in blood, Liam.

LIAM Yeah. Sorry about that.

 Beat.

 It's this lad's.

HELEN This lad's?

LIAM Yeah, it's this lad's

DANNY What lad's?

LIAM blood, it's this lad's.

DANNY Are you alright?

LIAM Yes. Yes, thank you, Danny, I am alright. Sorry. You
 should go back to your, it looks nice, is that your, is
 that your basmati…?

DANNY Yeah, it's

LIAM Yeah, it's not mine, it's this lad's blood. This poor
 fucking, just this poor lad's.

HELEN Has there been an accident?

LIAM Coming in like this, and you're having a dinner, like
 a celebratory

DANNY Its okay, don't worry, it's alright

HELEN Has there been an accident, Liam?

LIAM You do that, you do that, did you do that with
 lemon and olive oil, Danny? That rice you do, I
 love that, bit of the old cracked…?

HELEN So there has been an accident?

LIAM and I'm walking in like some sort of, some sort of
 fucking…

HELEN What sort of accident?

DANNY Helen, please…

LIAM It's gonna get cold, get all cold, Danny it's gonna get all fucking –

 Beat.

I come round the corner and he's

like, on the

fucking

lying, on the pave–, on the tarmac, on his own.

He's lying there on his own and I thought 'ah, no. Ah fuck, ah no, he's on he's own. He's on his fucking own.' And he was like an ordinary, Danny, you know, just like I don't know, I mean he looked like a decent, he looked, alright fair enough, maybe a bit you know, but like you'd have a drink with him though, I mean not necessarily a friend, but you might in a pub or something, if you just, if you just met, game of pool, a pint with, a decent pint with, am I rambling? I am, aren't I, I'm rambling, talking shit, fucking talking shite, and now he's lying there on his own, completely on his own. With blood. And like, and someone has…

some fucking…

someone has really –

 Suddenly overcome.

 They watch.

HELEN So what, there's been an accident, then?

DANNY Jesus Christ, Helen!

HELEN I'm just asking, Danny! I'm just trying to clarify –

DANNY He said it's not an accident

HELEN When? he didn't say… Liam, you didn't say

DANNY He did, he did say, he just said

HELEN He did not say that it was not –

LIAM That wasn't an accident.

She says nothing.

DANNY D'you wanna drink?

LIAM No thanks, could I have a glass of wine?

DANNY gets him some wine.

This country. It's just…monsters and… It's dark out there.

Sorry I didn't knock, I used the key. I know it's just, emergencies and stuff but I thought this might actually be a bit of a, you know, and I was thinking what if I knocked, Hels? and you see me it's like shock, someone like this, covered, but how do you not shock when you're covered, and then I panicked coz the door slams, that door, if you let it go, doesn't it, Danny, if you let it go it slams back, so I was gonna call out, but then I thought you'd shit your fucking bricks, and in your, Hels, you know, condition and what have you, you don't need to shit your fucking bricks in your condition and I don't mean that to sound in a patronising way, coz it's not like you're ill, you're not ill, or like you're ill or something, it's not like that, but still if you heard someone in the hall shouting out you would just shit your fucking, and that is not right. So I've been out there for about fifteen minutes really, not really knowing what to… you know…

do.

HELEN Liam, I want you to look at me.

LIAM Yeah.

HELEN Look at me.

21

LIAM I am looking at you.

HELEN Look at me.

LIAM Okay.

HELEN I want you to think. And I want you to tell me. Whose blood is this.

 Pause.

LIAM I tried to help him.

 DANNY gives him his drink.

DANNY The lad on the tarmac?

LIAM Yeah, the lad on the tarmac, and he's been hurt

DANNY By who?

LIAM By people.

HELEN By what people?

LIAM I dunno. I dunno what people. He was bleeding.

HELEN Where was he bleeding from?

LIAM Cuts.

DANNY From cuts?

LIAM Yeah.

DANNY And how did you help him, what did you do?

HELEN Why are you asking that?

DANNY So we know what he did.

HELEN Is that important?

DANNY It might be.

HELEN Liam, what did you do?

LIAM I shook him and said 'Mate, mate?' Like that.

DANNY You shook him?

LIAM Yeah, I shook him, I shook, I was just shaking him, but gently like, you know, and maybe a bit harder, because I was getting panicky

DANNY How hard did you shake him?

HELEN He was trying to help, Danny.

DANNY I'm just trying to establish

HELEN Okay, but please don't give him the second degree

DANNY I'm not giving him the second –

 Liam, sorry, I'm not giving you the second –

HELEN Where did the cuts come from?

LIAM Knives.

DANNY Knives? Someone cut him with knives?

LIAM On his chest and face and around his arms, like… slices

DANNY Fuck!

LIAM I think, I mean I dunno, maybe they weren't cuts, maybe they were…tears or something, rips

DANNY Not stabbed him? They cut him? They've sliced, they've actually…?

HELEN Was there anyone around, were you alone?

DANNY With knives?

LIAM I was alone, I was completely

 I hugged him. Sorry.

 Beat.

DANNY Was he conscious?

LIAM No

DANNY He wasn't conscious?

LIAM Yes.

DANNY He was unconscious?

HELEN Well if he wasn't conscious, Danny…

LIAM Yeah, he was unconscious.

DANNY Fuck.

HELEN Why did you hug him?

LIAM Coz…he was hurt. Sorry.

DANNY Jesus Christ! People have cut him with knives. They've literally cut him with knives and left him there, unconscious.

HELEN Where was this?

LIAM Markham Street. I mean round the corner.

DANNY They've literally cut him with knives on Markham Street and left him unconscious.

LIAM I was coming back from Ian's.

HELEN What were you doing at Ian's?

LIAM I just went to say Hello.

HELEN I thought you didn't like Ian?

LIAM I just went to say hello.

HELEN I thought you hated Ian?

LIAM Yeah, he's a cunt.

 This place, Helen. They do what they want. They run fucking riot. I'm scared to get the bus. Look what happened to Danny.

DANNY That was nothing. Kids, just, you know, kids or…

LIAM It's terrifying

HELEN Is he still there?

LIAM Who?

HELEN The lad. Is he still there? lying there, bleeding…?

DANNY Liam, is the lad still there?

LIAM He's gone.

DANNY What, he just got up?

HELEN What are you saying?

DANNY I'm asking, I'm just

HELEN You sound like you're cross examining

DANNY No, fuck, sorry, I didn't mean to –

 Fuck, sorry, Liam, I'm asking, I'm just

LIAM Yeah, he just got up and went.

DANNY But you said he was unconscious

HELEN Danny!

LIAM yeah, he just like, fucking, like a bolt, he just bolted
 up, he just bolted up and, you know, he bolted off.

DANNY What he just got up and ran off?

HELEN What is the matter with you?

DANNY I'm trying to establish

HELEN you're not fucking Petrocelli

LIAM he was just, like a bolt, Danny, he just bolted up,
 and he stared at me and he was covered in blood
 and his eyes were mad and ran off. He never said
 one fucking word, he just ran off.

 I feel really… I feel quite bad, actually

 I think you should move, Helen. You know. Shane
 and that.

Beat. Suddenly HELEN pulls at LIAM's tops, yanking it up and beginning to examine his body for marks. LIAM lets her do this, and DANNY just watches. Satisfied that he is okay, she lets him go. Beat.

DANNY Did you call anyone?

LIAM What?

DANNY Like the police or

LIAM No.

DANNY an ambulance, or

LIAM No, my phone's

DANNY So you didn't call anyone?

LIAM My phone's dead. I couldn't call anyone.

Beat.

I just wanted to, you know, help, but I didn't know what to do, I kept thinking what do I do, and I was thinking I should go back to Ian because Ian's done first aid, but I didn't want to leave him on his own, because Ian's a cunt anyway and because he's a person, you know, he's like a person, lying there and you can't leave a person, just lying, in the street, lying on the ground, on the tarmac

DANNY This is insane, are you okay?

LIAM Yeah, yeah, no, I'm alright. Actually. I'm fine. I'm fine, actually, yeah, this is

He is crying, though he tries not to.

No, I'm...

DANNY Liam?

LIAM Ahhh, shit. Shit, shit, shit, look at me, look at this, you're having dinner, celebration, celebratory,

HELEN we're not celebrating, we're just

LIAM and I'm coming in like some sort of

HELEN Don't worry about that, Liam.

DANNY Liam, do not worry about that.

LIAM rice, and

HELEN That's fine, Liam

LIAM I think you should move, Helen. This area...
Because out there...? Animals, not kids, fucking...

He is crying.

She goes to hug him, but he pulls away.

Nah, nah, I got blood, I got blood all on me.

Sorry, fucking tears, and, what a cunt.

HELEN You're not a cunt.

LIAM I am, I'm a cunt.

HELEN You are not a cunt.

DANNY You're not a cunt, Liam.

LIAM Do you think I could have a hug, Helen?

HELEN Come here...

LIAM (*Pulling away.*) Nah, nah, the blood, the blood

HELEN Alright, look, we're gonna get you cleaned

LIAM This top's fucked

HELEN You can wear one of Danny's, can't he Danny?

DANNY Yeah, of course.

LIAM It was a present from Jeanie. Jeanie got me this
Hels, it was a

HELEN I know, but we can clean it.

LIAM Nah, it's fucked. I've fucked it

HELEN You haven't fucked it

DANNY Which one?

HELEN 'Which one'?

DANNY Just take any of them, Liam. Any of them's fine.

LIAM Thanks, Danny, thanks, you're –

 He hugs DANNY. DANNY keeps him at a distance so as not to get blood on him.

Sorry. Sorry.

 HELEN takes LIAM off.

 DANNY sits at the table. Looks at the food, hungry. Pokes at the rice with his fork. Puts the fork down. Considers. Decides. Lifts a fork-full of rice to his mouth.

 HELEN enters and he puts the rice down. She carries a blue top.

HELEN Are you eating?

DANNY No.

HELEN I'm gonna give Liam this to wear, is that okay?

DANNY Yeah. Is that my blue one?

HELEN It's your blue one.

DANNY Don't give him that, Helen, give him the green t-shirt

HELEN Why?

DANNY Helen, please give him the green one, that's the blue one, that's new

HELEN What green t-shirt?

DANNY The one with eagle-star on it.

HELEN it's in the wash

DANNY Fucking hell, Helen…

HELEN Eagle-star?

DANNY Did you tell Liam you were pregnant?

> *Beat.*

HELEN Yes.

Is that a problem?

DANNY No.

HELEN Why is that a problem?

DANNY We only found out on Monday, I mean shouldn't
we wait until

HELEN Shit, sorry, Danny. I mean

DANNY three months or – no, no, Helen, I'm not having a,
it's not a problem, it's a question, I'm just

HELEN Sorry, shit, I just

DANNY No, no, Helen, I'm not, it's not a problem, I'm not

HELEN I just needed

DANNY having a go, or

HELEN someone to talk to.

> *Beat.*

DANNY Oh. Alright.

> *Pause.*

HELEN Look, if you wanna eat something, just eat.

DANNY No, I'll wait for you.

HELÉN Just eat.

DANNY No, I'll wait for you.

Pause. A moment.

HELEN Fuck.

DANNY I know.

HELEN Poor Liam.

DANNY I know.

Is he alright?

HELEN Yeah. Yeah.

I think so. What do you think?

DANNY Yeah, yeah. I think he's alright.

He's strong.

HELEN He's not strong, Danny.

DANNY No, he's not strong.

HELEN Thank you for this. You know, for being so…with all this

DANNY What? Jesus, no, I mean it's, it's Liam. I mean he's…part of us…

HELEN And sorry I'm a bit…you know

DANNY No, no, god, no, you're not, not at all

HELEN Oh, I am. I am a bit.

DANNY You're not, you're really, really not.

HELEN Well. Thank you anyway. I mean that, Danny.

Pause. She looks at the food. Touches him.

So much for our special evening.

DANNY I know. Never mind.

We should be able to get another in one when Shane discovers drugs

Beat.

HELEN Are you being sarcastic?

DANNY No, it was a joke.

She is staring at him.

I was joking

HELEN Sorry, Danny. Christ, sorry.

She hugs him. He returns it.

You should make them funny, then I'd be ready for them.

They break the hug, but still close, touching.

DANNY Why did you need someone to talk to?

What, in a bad way?

HELEN No, not in a bad way, Danny, I just needed

DANNY Because, you can talk to me.

HELEN I can't talk to you.

DANNY Why can't you talk to me?

HELEN Would you talk to me?

DANNY Yes.

HELEN What, you would talk to me?

DANNY Yes.

HELEN If you, like, needed

DANNY Yes, yes

HELEN to talk, chat about, you would talk with me, would you?

DANNY Yes, I would talk to you.

Beat.

HELEN Well that's not how most people work.

DANNY What did you need to talk about?

HELEN Have I done something wrong?

DANNY No, no, god, I'm not

HELEN telling my brother, did you not want me to, because

DANNY No, Helen, of course, no, no –

HELEN Good.

Beat.

DANNY Listen, Liam's gonna be fine. We'll make sure he is.

She smiles at him. A moment.

HELEN I'd better give him the shirt. Eagle-star?

DANNY Yeah, the green one.

I'll call the police.

HELEN Okay.

He goes to the phone.

What?

He stops. Looks at her.

Sorry, what are you –?

DANNY Calling the police.

HELEN Right.

DANNY I mean we've got to call –

HELEN Oh yeah, course.

DANNY Don't we, I mean we have to

HELEN Oh, yeah, yeah. Course.

DANNY Shall I do it while you're in there?

HELEN Great. Why?

 Beat.

DANNY 'Why?'

HELEN Danny, hang on, just give me a minute, Liam's in
 there –

DANNY 'Why?' Someone's been hurt.

HELEN I know, but

DANNY So we should call the police

HELEN Just hang on, is all I'm saying, a minute,

DANNY What for?

HELEN is all I'm saying,

 look, don't do one of your panics, please, this is

DANNY What?

HELEN let's just think, for five minutes

DANNY What's there to think about?

HELEN because this is all a bit mad, and we're, you know

DANNY Are you saying we should *not* call the police?

HELEN No, definitely not.

DANNY Is that what you're saying? Are you saying that we
 should not –

HELEN I am definitely not saying that, that is something I
 am not saying, but I am saying can we just, for a

minute, for five minutes, without panicking, without flapping think first, please.

DANNY I do not flap.

HELEN Because this is my brother.

DANNY I know it's your brother.

HELEN He's the only family I've –

DANNY I know he's the only family you've got.

HELEN Well don't say it like I'm boring you.

Beat.

They're going to think Liam had something to do with it.

DANNY No they're not.

HELEN They are, yes, they are, because he's always, he's unlucky, Danny, you know he's unlucky, he has a record because he's unlucky, and

DANNY What are you talking about? They are not going to think that.

Silence. She stares at him.

What?

HELEN Right.

Right, okay, right. You know when you were in Miami?

Beat.

DANNY When?

HELEN When you were in Miami.

DANNY When?

HELEN When you were in fucking, when you were –

DANNY When? When? what time, I've been there three
 times, what

HELEN The last time, the last fucking time, I'm talking
 about the last

DANNY Well I don't know that, do I?

HELEN Well why would I start a sentence like that if I didn't
 mean –

 The last time, Danny, the last time you were in
 Miami.

DANNY Okay, okay!

 April.

 Beat.

HELEN The time before that.

DANNY November.

HELEN November, yes, well when you were in Miami in
 November this thing happened and

 and the police came round, but

DANNY What?

HELEN No, no, it's fine, he was completely innocent, he was
 with me the whole time

DANNY The police came round?

HELEN so it wasn't anything, you know the way he stays
 when you're not here, you know how protective he
 gets, so he was here with us, so

DANNY The police came round here?

HELEN Yeah, but that's not important, it was completely a
 mistake, they said it was a mistake and everything's
 fine, but the thing is

DANNY Not important? Why didn't you tell me?

HELEN Because, it's not... Danny, you're fixating on the wrong thing, it's not about that

DANNY Why didn't you say anything?

HELEN Because Liam didn't want me to.

DANNY Why?

HELEN Because he fucking adores you and he made me promise not to tell you, but that's not why I'm telling you, so can I please tell you why I'm telling you, please?

DANNY The police came round here?

 Beat.

HELEN Look, the thing is, I mean the thing is they were on a mission. They were on a mission, Danny. Right, this bloke gets hurt and someone, some scumbag said Liam's name and he's not even there, no-one thinks he's there, no-one, but some scumbag says Liam's name and because Liam has a record, because he's unlucky, Danny, and yes, stupid, he's done stupid things but a long time ago, but they did not give one single solitary fuck, they were on a mission.

You see you think, right, and I'm not criticising, but you think that things work out fair, but things don't. Not for people like Liam. They really don't. This isn't the fair world you think it is, Danny, and I'm not saying what you believe and think is wrong because I love you for that, but now is not the time for that, because this is now. They are going to think Liam had something to do with this.

Please. He can't handle this, not now. Please, Danny.

Pause.

DANNY Liam's innocent, Helen. He hasn't done anything.
He has nothing to fear from the police, he is
innocent. There is a boy, out there now, hurt. We
have to call.

Pause.

HELEN You are so…

you are so fucking…

you are so…

DANNY What, what are you –

HELEN How can you be so, I mean Jesus Christ, how can
you be so fucking naïve? How can you walk around
like, you walk around like nothing in the world is
and then these boys, these fucking boys! You know,
and you go on as if they're innocent and it's your
fault, our fault for breath, excuse me for fucking
breathing a fucking breath, I fucking…

DANNY Jesus Christ, Helen, I'm–

HELEN Alright, well let's not have this child then.

Beat.

DANNY What?

HELEN You know, if that's… how, if you're gonna be all,
if that's what you, if that's you're thinking Danny,
then what's the bloody point in, let's not bloody
well, we, we, we shouldn't, into this world at all,
then.

Beat.

DANNY Helen… do you mean that?

Beat.

HELEN What?

DANNY Do you mean...?

HELEN No.

DANNY I mean do you, have you been thinking...?

HELEN Yes.

DANNY Yes?

HELEN No. Maybe.

 I don't know. Maybe. Maybe yes. Maybe I do. Shit.

DANNY Are you serious?

Pause. She is thinking.

HELEN Okay. Look, no we can't, that's not for now, because, Liam, I mean Liam is in there, so... Yeah, yes, okay, we can talk about, like later, because now we have to take care of

DANNY Is this something that you've been thinking?

HELEN so, so, so I'm just gonna, because he's in there, half naked

DANNY Fucking hell, Jesus fucking

HELEN Because I've just got to give him the, because he's standing in there half naked, so alright, yes, I'm going to give him the... Okay?

She goes. DANNY sits back down.

Looks at the rice. Thinks.

LIAM comes in wearing DANNY's eagle-star t-shirt.

LIAM Jeannie gimme that shirt. Helen said it'll be alright, d'you think it'll be alright?

DANNY What?

LIAM D'you think that'll come out, what gets blood out?

 DANNY just stares at him.

 It's just that Jeanie gave me that shirt. Christmas
 present, last thing she gave me, you think that'll just
 wash, just wash out Danny?

DANNY Yeah, it'll probably just wash out, Liam.

 Beat.

LIAM Thanks for lending me this.

DANNY You're welcome.

LIAM What deodorant do you use?

DANNY Er, Lynx, I think.

LIAM Yeah, nice.

 Beat.

 You alright, Danny?

DANNY What? Me? Yeah, yeah, I'm fine.

LIAM You sure?

DANNY Yeah, I'm

LIAM You're having dinner and this turns up.

DANNY Liam, you're always welcome, you know you are

LIAM Yeah, but you know…

DANNY We gave you a key, you know you're…

LIAM And I appreciate that. I don't forget that

 Beat.

 You alright after all…that?

 *He makes a vague gesture. At first DANNY doesn't get
 it, but then…*

DANNY What? Oh, yeah, yeah no it was just

LIAM Fucked.

DANNY Fucked, yeah, but

LIAM I mean fucking hell

DANNY Yeah, but you know, it's just one of those things

LIAM There's nothing you can do. There's too many of them and they know that, the little cunts.

DANNY They do, there was nothing –

LIAM You're not less of a man.

 Beat.

DANNY I know.

LIAM Asians, were they?

 Beat.

DANNY Well, some of them, but I don't think –

LIAM No, I don't mean it like that.

DANNY I mean I don't think that was

LIAM Yeah, no, Danny, not at all, I mean that's all fucked that sort of

DANNY a factor

LIAM racial, I mean, no. Ian's like that and he makes me fucking sick. Giving it all 'The Asians this and the Asians that.'

DANNY Yeah

LIAM and 'I'd like to cut open a fucking nigger's stomach' makes me sick, Danny, makes me sick, that sorta talk. Makes me wanna fucking hit him, actually, and Ian gives it all that but he ain't exactly a big man, cut open your stomach, see what you think.

DANNY He's a bit of a prick.

LIAM Yeah.

 He's a mate though, so…

 Pause.

 You wanna talk about it?

DANNY What?

LIAM You know. Talk about it?

DANNY No. It's fine, Liam.

LIAM I'm shaking.

DANNY Are you?

LIAM Yeah, look.

 He puts his hand on DANNY's forearm.

DANNY Yeah.

LIAM Fucking hell, eh?

DANNY Yeah, you're

LIAM Like a leaf.

 Beat.

 I tell everyone about you, all my mates. You're
 living proof of what you can achieve. You're
 brilliant. This area, though, Danny, you know. You
 should take Shane out of here. Man of the family
 and all that.

DANNY Yeah, yeah. It's not that bad.

 It's good for transport. And they're opening a coffee
 shop round the corner, so –

LIAM I hate violence. It makes me cry. Always has, you
 ask Helen. You ask her, you ask her about Brian

41

Hargreaves, I cried like a baby when he got hurt. She saw me through that, she was like an angel, an angel sent from god, I used to thank god that he'd given me one of his angels for a sister, don't tell Helen that, but I did actually think that's what he'd done, Jesus, I'm just jabbering shit, sorry, sorry

DANNY It's fine, Liam.

LIAM I was so happy when you two got together. I was over the moon when she told me you were getting married. I cried when she said she was carrying your child. I always knew she'd make a great mother, she could've abandoned me, could've let them split us up, that's what they wanted, they used to look at us and think we could really place that girl, but that boy... I know that, Helen doesn't know I know, but I know. And she never once allowed that, and more than that, Danny. Never even entertained the thought.

We're abandoned here. Government? Fucking left us to beasts, and that's not blaming it on the Asians, Danny, coz they're good people some of them, some of them are very, very good people, not the cunts that did you, or hurt other people, go around hurting, they're scum, they're filth, but some of them...victims. Victims of prejudice.

DANNY Your hand.

LIAM What?

Realises. Take his hand away.

Oh, sorry, Danny, sorry, I'm fucking... Brain's gone to shit.

Where's Shane?

DANNY At his Gran's.

LIAM Ah, shit, fuck, look at me. Gone to pieces, brain's gone all –

> *HELEN comes through with the top, soaking wet. She goes straight into the kitchen without looking at them.*

D'you think it'll be alright, Helen?

> *But she has gone. Pause.*

Jeanie used to tell us these stories, you know, and they were shit like, you know, I mean they never used to go anywhere and afterwards we'd be like in fits of laughter coz she'd just told us this story that went fucking nowhere, fucking nowhere, Danny. Yeah. Like you'd get a bedtime story about a horse named Darby and basically it's a talking horse and it'd have an owner who'd take it to market and at the market he'd meet an old friend and go off for a drink and the friend would ask the owner if he needed a job and he'd say yes and they'd go back to this bloke's farm where they'd work together bringing in the corn and his wife would get ill but then a doctor would come and heal her, and that be the story, that'd be the fucking story and we'd be like in fits of laughter, but Jeanie, wouldn't get it, she'd carry on, and we're going 'but what about the talking horse' but she was never bothered like, she'd just carry on. She was an angel. We wished we coulda stayed with her. Kept in touch all those years.

DANNY I wish I'd met her.

LIAM Thanks Danny. Thank you for that.

You think it matters how hard I shook him?

Because you asked how hard, and, I mean d'you think –

DANNY Liam, I think you were trying to help and your natural instincts wouldn't've let you do anything to harm him

LIAM D'you think so?

DANNY Definitely.

LIAM Okay. Okay.

Beat.

Okay.

HELEN re-enters. Long pause.

HELEN I'm not sure that calling the police will help.

Pause.

Danny wants to call the police, Liam.

LIAM Does he?

HELEN When you were in there he said he wanted to call the police.

Beat.

Well, did you say you wanted to call the police?

DANNY I…suggested…

Liam, I suggested

LIAM No, no, fair enough

DANNY I suggested, Liam, because

LIAM No, fair enough, Danny, you're right, course. We should, we should…

HELEN What, call the police?

DANNY We should, shouldn't we? Liam, I mean shouldn't we…?

LIAM Don't you think, Hels?

44

HELEN I don't know, do you?

LIAM He was hurt.

DANNY I mean what if it was us?

HELEN It wasn't us.

DANNY What does that mean?

HELEN I'm just saying, it wasn't us, so what's the point in saying something was something when something wasn't something?

DANNY Someone's been hurt, Helen! Someone has hurt another person. Someone is bleeding, someone is bleeding now.

HELEN Someone who might be involved, for all we know.

DANNY Involved? Involved in what?

 Beat.

HELEN Right. Right. He got up and ran away.

DANNY And that means he was involved in something?

HELEN I don't know, I don't know, Danny, but there was violence. There was at least a violent thing that he might have been involved in, or might not, but just say he was and we call the police and basically put Liam through all that for someone who, well, who might be...well, dodgy.

DANNY Dodgy?

LIAM I don't think he was dodgy, Hels.

HELEN I mean he got up and ran off,

DANNY He was terrified!

HELEN Exactly! He was hurt but he didn't stay there? What's going on, think, Danny, I mean Christ, what was he wearing?

DANNY What's that got to do with

LIAM ah you know

DANNY We can't judge him on

LIAM all the gear

HELEN I mean round here? a lad, hurt? lying on the floor, wearing all the gear? what's he been involved in, what's he running from?

LIAM No, Hels, I don't think, definitely, I don't think he was

HELEN Because I tell you one thing, I am sick of this place. I am sick of the people I love, my people being subordinate to the people out there, people who basically do what they want, run around, calling me a cunt, yes, Danny, because that happens Danny, when I'm with Shane, Danny, bitch this, and bitch that and you just want to close your eyes?

DANNY No, I don't want to –

HELEN Show us your cunt, bitch, how's your cunt today, bitch, can I lick your cunt, bitch, show us your cunt you cunt. And you do nothing.

DANNY What do you want me to do?

 Beat.

HELEN All I'm saying is that Liam has a record. He has a record. I'm saying that the police are going to be suspicious.

LIAM Are they?

HELEN Of course they are

LIAM Yeah. They might be suspicious.

HELEN They're the police, Liam, they're paid to be suspicious. He has a record. He has a record,

Danny, I'm asking you please just to think about that. There is a lad covered in blood and it's all over Liam's shirt

LIAM You just washed it

HELEN That doesn't matter Liam, there'll be DNA, that stuff never comes out, and how is that going to look? The first thing we do is try and clean the evidence

LIAM Evidence?

HELEN Yes!

LIAM Does that look bad?

HELEN Washing the evidence? Does that look bad?

DANNY Then why did you wash it?

HELEN Because it was covered in fucking blood!

And will it help? Will it help anyone? This lad, who may or may not have been involved in something, and I'm not judging him, I don't know him, but I know people like him. And who are we helping? Someone who gets up with these cuts of his and runs off into the night, running from something and we don't know what that is, will it help him to call the police? Liam gets guilty if you so much as look at him.

LIAM I go bright red if I talk to the police.

HELEN He tried to help. Is that a bad thing? Should he be punished for that?

LIAM They make me feel guilty, the cunts.

HELEN For someone we've never met? My brother for some...lad we've never met?

Beat.

47

DANNY It's a person. There is a person out there.

HELEN Not a person I know.

DANNY What do you mean I do nothing? What do you
 expect me to do?

 Pause.

HELEN If this boy is innocent I feel very sorry for him. If he
 isn't, then I don't. But I don't know him.

DANNY Is that what the world comes down to these days,
 then? Who we know and who we don't know?

HELEN Yes.

 Yes, it does, Danny. Today. These days. These days
 that is exactly what the world comes down to. Who
 we know, and who we don't know. Sorry.

 Pause.

 What I would like you to do...

 What I would like you to do, Danny...

TWO

Later.

LIAM, HELEN and DANNY, sitting at the table.

LIAM is eating, tucking into the salmon and rice.

They watch. He eats, enjoying his food as if they weren't there.

Silence, just the sound of LIAM eating.

He finishes. Pushes back his plate

HELEN What were you doing at Ian's?

LIAM Ah, he's a mate.

HELEN He's not a mate, Liam

LIAM No, he's not.

HELEN He's a bad influence.

LIAM That was beautiful, Danny, that was

HELEN He collects Nazi memorabilia.

LIAM He don't collect it, he's just got some. Gets it off the internet.

HELEN You shouldn't go round there.

LIAM Yeah, he's got like loads, really sick it is, got like letters, jackets, canisters of zyklon B, it's sick, it's really sick. It's mad, it's really disturbed stuff, Danny, though some of it is amazing.

HELEN You should stay away.

LIAM I said to him, that's sick and he just laughed. Some of it is really amazing, though, he's got a Luger with SS on the hilt

HELEN That's sick

LIAM That's what I say, it's sick, but it's amazing as well and he's getting into all modern stuff, got this machete, reckons it's from Rwanda, getting all into all stuff from Iraq and Afghanistan, reckons he's gonna get a severed hand from the Democratic Republic of Congo. Downloads all those videos, like violence, gang violence and shooting beatings and beheadings, jihadist whatnot, he loves all them sites.

HELEN Were you watching them?

LIAM No.

 Beat.

 Some of them are terrible.

HELEN You shouldn't see him.

LIAM I don't even like him, but he's a mate, you know.

 We was at school together, so.

 He gets up. Stands there.

HELEN What are you getting up for?

LIAM No reason.

HELEN Why don't you sit down?

LIAM Okay.

 He sits. Long pause.

 Can't just abandon people.

 That rice was lovely, Danny. Simple, just simple ingredients, that's what I love about your cooking: lemon, cracked pepper and a good olive oil – what could possibly go wrong? Just simple, Italian, it's quite Italian really, see I wouldn't think about that, I love cooking but I'm a vulgar cook, I'd put loads in, spices, herbs, oils, pastes, fucking shit loads, I make food like I'm mixing cement, I know I'm doing it

but I can't stop, the only thing I can really make is chilli, I'm a vulgar cook, Danny. That was fucking beautiful.

DANNY I can't believe we're doing this.

HELEN No, well, we are. We've made a decision so let's –

DANNY I know we've made a decision, I'm just saying.

 Silence.

LIAM There's… There's a steam fair up the park, did you see that, Danny?

DANNY No.

LIAM Yeah. No, not now, next week, the weekend, they're having it like, there's posters up there, you know. Steam fair next week, sort of thing.

DANNY Is there?

LIAM Yeah.

 Beat. He stands up.

 Yeah, it's good they do that sort of thing, they do a lot of that sort of thing in that park, it's good.

DANNY What's a steam fair?

LIAM I'm not sure, as it goes.

DANNY Is it a fair?

LIAM No, it's not a fair.

DANNY Not rides

LIAM No, I don't think so, I mean if it is I don't think it's very quick coz it's all steam.

HELEN Why don't you sit down?

LIAM Yeah, it's like steam things, just like big steam, like a steam tractor or a big fucking steam, engine, or something.

DANNY Right.

LIAM Maybe like a carousel, but like it's steam, you know, so it's not gonna go very fast.

HELEN Why don't you sit down, Liam?

He sits.

LIAM Tea cups, you know.

HELEN Tea cups?

LIAM Yeah.

No I mean if you sit in a tea cup or something.

HELEN What tea cups?

LIAM It's for the kids, you know them things, them rides, for

HELEN No, I don't know

LIAM for kids, where they're in a tea cup, carousel, you know the things.

HELEN No, I don't know steam powered carousels with tea cups for kids.

LIAM Well, I think it might be like that, I dunno, I'm just guessing.

Pause.

I was thinking of taking Shane.

DANNY Oh.

Yeah, yeah, he'd love that.

LIAM Thinking of taking him at the weekend.

DANNY Yeah he'd love that, Liam.

LIAM Great.

HELEN What are you talking about?

　　　　Beat.

LIAM Taking Shane –

HELEN In the park?

LIAM Yeah.

HELEN It's in the park?

LIAM Yeah, but it's –

HELEN You're thinking of taking a five year old to a fair in that park?

LIAM Yeah, but it's in the day, Helen.

HELEN A fair? Kids hanging out and stabbing each other?

DANNY It's a steam fair, Helen.

HELEN You don't even know what a steam fair is, you're worse than him.

LIAM It's in the day, it'll be fine, it's a family thing.

HELEN He's not going up that park.

DANNY It's in the day…

HELEN Are you two insane, he's just walked in covered in blood!

DANNY It's in the day

HELEN No way.

LIAM He'll love it, Hels, it's like these steam engines and stuff, it's a family thing, there's gonna be families there and –

HELEN Do you want some coffee?

LIAM No.

HELEN Do you want some coffee?

DANNY No.

 LIAM gets up.

 What are you getting up for?

LIAM I dunno. I just feel a bit… Is it hot in here?

 I think I'll stay up.

HELEN Sorry, I'm snapping, but…you know. I don't mean
 to snap, but…

DANNY What time is it?

 HELEN looks to LIAM.

LIAM My phone's dead.

 She gets up. Goes to her phone. Looks. Sits back down.

HELEN Five past nine.

DANNY Do you think he's alright? What past nine?

HELEN Five past.

 Long pause.

LIAM Fucking tense this, innit.

DANNY Maybe we should go out and look for him?

HELEN What, now?

DANNY Yeah. Check he's

 I mean alright, we've made a decision and we're
 not calling, and I agree, I'm with that, but he's out
 there, maybe hurt, maybe, I don't know, so maybe
 we should…check.

HELEN Out there?

DANNY Yeah.

HELEN Could do. Yeah, I suppose we could do. But…

 I mean the sun's gone down. It's dark…

DANNY He's a human being. Whatever else he's done,
 he's a human being, and I agree, we've got to look
 after Liam and, and ourselves, but aren't we a bit
 responsible for

HELEN Yeah, we are, you're right, but…

DANNY our fellow, I mean isn't that what we hate?

HELEN Oh we do, yeah, but

DANNY fuck you and I'm alright Jack and all that old

HELEN Oh, yeah, we do, definitely, hate that, you're right,
 but, I mean it's dark

DANNY It is. But this is important.

HELEN On your own?

DANNY What? No, well I was thinking me and Liam…

HELEN Liam can't go.

LIAM I'm not going out there, Danny

HELEN He's gotta stay away from it.

LIAM I'm shitting it Danny, I can't go out there

DANNY Right, right, fair enough.

HELEN You wanna go on your own? At this time?

DANNY Well…

HELEN After dark?

LIAM I admire that. After what happened to you

DANNY Oh, just kids and

LIAM Kids? Cunts.

DANNY and I was a bit drunk, so…

HELEN Maybe it's not a bad idea. To see.

DANNY Yeah, yeah. Maybe.

 Which, which way did he go, Liam?

LIAM Away from the shops.

DANNY Right.

 Into the…

LIAM Into the estate, yeah.

DANNY Right. Right.

 Right.

 Pause.

HELEN I think you should stay here with us.

DANNY You're probably right.

 Silence. They wait.

LIAM Tense.

 Pause.

 Shanie excited?

 No answer.

 Little brother? Bet he's excited. Or sister, could be,
 couldn't it, sister, little sister, that'd be lovely, I bet
 he'd love a little

HELEN Don't say anything to Shane, Liam.

LIAM What? No, no, if you don't want me to –

HELEN I mean that, don't you say anything to –

LIAM No, no I won't

HELEN Don't you fucking say a word to –

LIAM I won't, Hels, I won't!

 Pause.

 Why?

HELEN Because…

 Pause.

LIAM What?

 Beat.

 What?

 Hels? What?

 Pause.

HELEN Look, we're not

 one hundred per cent… about…

 Pause.

LIAM What?

HELEN It's just

LIAM You're joking.

 Why?

 She says nothing.

 Why?

HELEN I don't think this is the right time to discuss

LIAM Yeah, course, sorry, no.

 Beat.

 Don't. Please don't.

Sorry, fuck, sorry. Sorry, Danny. Sorry, Hels, none of my business, none of my fucking, but don't, Hels. I mean Christ, you're such, you two are such great parents and Shanie's such a great little man.

HELEN I don't think

this is the right time to talk about

LIAM I'm so sorry Hels, I'm so sorry Danny, this isn't the right time to talk about this at all, and it's none of my, not at all

But I don't understand why? I thought you wanted more?

HELEN Yeah, we…we do originally, I mean originally

LIAM I thought that was the plan

HELEN That was, yes, the plan originally, originally that was…

DANNY Originally?

Beat.

Look, nothing's decided, Liam, we haven't even, I mean me and Danny haven't even really, have we, properly yet, so. But we were thinking that maybe, with the way things are, the question is, circumstances, you know living here and, and, and giving up my job as well, that's definitely, and at the moment maybe that isn't the right… possibly.

LIAM I don't understand.

HELEN Look. We just think maybe this isn't the right –

DANNY You.

Pause.

HELEN What?

DANNY You just think. Not we. You.

>*Beat.*

>I want it. I want our child. I don't understand why you don't. Why don't you want it?

HELEN I...

DANNY I keep touching your stomach. Haven't you noticed me touching your stomach? I keep touching your stomach because I want to touch it, him, her, I want to touch him or her, I want to touch him or her and I want to push love for him or her through my hand, through your stomach, through your womb and into our child, so that he or she knows that he or she is loved.

HELEN I didn't

>I didn't say I didn't want it.

>I said...there's a –

>You're not making this, Danny, this is –

>I said there's a...doubt.

DANNY Why is there a doubt? Why do you have a doubt? I don't have a doubt, why do you have a doubt? Why do you now have a doubt about having this child with me?

>*Pause. They are looking at her. Cornered.*

HELEN You want me to...?

DANNY Yes.

HELEN You want me to say, in front of...?

DANNY Yes

>*Pause.*

HELEN I'm not...

When I look at this, our life, or lives, here, I'm not, if I'm honest, one hundred per cent that it is entirely working or working out to, or in such a way, as, as, as well as we might have

been led to believe

expectations... allow.

> *Beat.*

DANNY What?

HELEN I'm, you know, I think, maybe this has made me think about

DANNY Expectations?

HELEN and on balance, looking at everything, and are we comfortable bringing another, and it's just a question, I'm not accusing and it's me, us, both, Danny, but the question is still there.

DANNY Expecta...? What fucking question?

HELEN Look.

Alright, Danny, Look. I'm... I'm just not one hundred per cent sure our life, it's what we

DANNY You

HELEN thought it was going to be when, when, when we

DANNY When you

HELEN Danny, that's not helping, that really...

> *Beat.*

Look, I'm, I'm not saying that we are

DANNY You are

HELEN That we are talking about

DANNY that you are talking about

HELEN I'm not saying that we are talking about.

DANNY you're not saying that you are talking about

HELEN ending, no, not at all, because we are

DANNY You are

HELEN You are such a piece of shit, you are such a piece of shit sometimes, sometimes you are such, such a fucking piece of…

Sometimes I look at you and I fucking…

I fucking…

Beat. She sits.

Silence. For a long time.

LIAM You been up the grave?

Long pause.

HELEN Mum and Dad's or Jeanie's?

LIAM Jeanie's.

HELEN Yeah, I was up there…

Beat.

Not in a while.

LIAM no, no, she won't mind, she knows how busy you are, and I was up there last week, so…

What about Mum and Dad's?

Beat.

HELEN I've been meaning to.

I was thinking of going next week.

LIAM Ah, that's great, Hels, yeah.

HELEN Yeah, maybe Tuesday.

LIAM I could come with you if you like.

HELEN Yeah. No, I've got an early on Tuesday, so

LIAM Right

HELEN maybe, later

LIAM Yeah, course

HELEN Maybe Friday. Maybe I'll go Friday.

You wanna come on Friday?

LIAM Yeah. Brilliant.

> *Beat.*

I always say hello anyway, when I go up I say hello for you. I say 'Helen says hello.' I tell them what you been up to.

HELEN Thanks.

LIAM They're so proud.

They're so proud of you, Helen. You and Danny, and everything you are, you know.

> *Long pause.*

HELEN I'm sorry, Danny, that was a bit, you know. But you…

> *Pause*

So it's a family thing? This steam thing?

LIAM Yeah, I think so, I asked the guy up there and he said it's just for the kids.

HELEN Right.

LIAM Yeah. He said it'll be full of families.

> *Beat.*

Plus the odd dirty old man with a beard.

Beat.

HELEN What?

LIAM What?

HELEN Is that supposed to be a joke?

LIAM What?

Beat.

Oh, no, not

HELEN Is that supposed to be funny?

LIAM No, no, I wasn't, I don't mean, not paedo

HELEN That's not funny, Liam.

LIAM enthusiasts, like steam

HELEN You said dirty old men with beards

LIAM I meant enthusiasts, not paedos

HELEN You said –

LIAM I meant steam enthusiasts

HELEN You said…

LIAM God, no, I'm sorry, I'm sorry, Helen, I meant like dirty because of the engines and –

 Ah, Jesus, what am I saying…

 I'm sorry, Helen, I don't know what I'm saying

HELEN It's alright

LIAM I'm all, look at me, I'm all

HELEN It's alright, Liam.

LIAM Is it fucking hot in here or what?

HELEN What time would he be back?

LIAM Oh, it's a morning thing, have him back here by one.

HELEN Right.

Well, maybe…

Pause.

I think I'm meeting Sarah on Friday, but maybe we could go to see Mum and Dad some time the week after.

DANNY So we're going to let whatever's going to happen to him happen to him. Because he's not one of us.

They stare at him.

No, I just want to be clear. Because if we're going to do this we should be clear.

HELEN We're not doing anything.

DANNY Because we've made a decision, haven't we. We've looked at the situation, accepted it, summed it up and made a decision to do nothing. Because he's not one of us.

HELEN Danny…

DANNY So if we choose, knowing that he's hurt – not by us, by someone else, but still – but we choose to do nothing and if he's losing blood and that's hurting his body, if that is causing damage to his system, then we are choosing to allow something that causes damage to his system and is that the same as choosing to cause damage to his system?

LIAM Do you think it's damaging his system?

DANNY I don't know Liam, that's what bleeding is.

HELEN Why are you doing this? Don't, Danny, really don't

LIAM I mean do you think he's in danger?

DANNY I don't know, Liam. But just say that we knew he was going to die…

HELEN For fuck's sake, Danny!

DANNY No, I'm just saying that if we did know that, and we took a decision to let him die, then what sort of people would we be?

HELEN He's not going to die

DANNY because he's a lad, he's wearing

LIAM I mean d'you think he's… How long does it take?

DANNY What, to bleed?

HELEN He's gone to a hospital, Liam, he's probably in a hospital right now –

DANNY To bleed to death?

HELEN Don't say bleed to death!

LIAM But if he didn't, Hels, if he didn't go

DANNY If he didn't we don't know, Liam, I mean how bad was he hurt?

HELEN He got up and ran off!

DANNY There was a lot of blood

HELEN Danny, please

DANNY I'm just saying

HELEN I know you're just saying but you're winding Liam up and he's winding you up and together you're blowing this all out of proportion

Beat. Pleading look from HELEN.

DANNY Okay, right, okay; he's not going to die, this boy

LIAM D'you think so?

DANNY I don't know, Liam, but say he isn't. Alright? Say
 he isn't, but what if that's wrong? And what if he is,
 what if he is in fact going to die?

HELEN Jesus Christ...

DANNY And forget the courts and prosecution and charges,
 the courts, even if no-one ever finds out that we
 do nothing, we deliberately did nothing, we took a
 choice to do nothing, and he dies, how do we live
 with that?

LIAM because he looked hurt.

HELEN You prick.

LIAM because he looked hurt bad, actually, Hels, and I'm
 a bit worried as it goes

HELEN He'll have gone to hospital, Liam he will now be
 in a –

LIAM What if he couldn't?

DANNY Well, if he couldn't, I don't know, there was a lot of
 blood.

HELEN Danny, please don't, because this is too serious, to

DANNY What? What's the matter?

HELEN You know. You know what's the matter.

DANNY What, is this not meeting your expectations?

HELEN You are such a fucking coward

DANNY Oh, here it comes

HELEN This is your answer? Is this your fucking answer?

DANNY Yes. This is my cowardly answer.

HELEN And you wonder why, if, you wonder why –

LIAM But say if he didn't Hels?

HELEN Who?

LIAM The Asian lad

 Pause. Silence.

HELEN What Asian lad?

LIAM What?

HELEN What Asian lad. You didn't say he was Asian.

LIAM Didn't I?

HELEN No.

 Beat.

LIAM Well he was

HELEN You didn't say

LIAM I didn't think

HELEN Right

LIAM it was important

DANNY He was Asian?

LIAM Yeah, but I didn't think

DANNY You didn't say he was Asian

LIAM I just didn't think it was, you know…

DANNY Okay.

LIAM Coz it doesn't really

 matter, because I'm not really, you know, his
 colour, his creed, I'm not really, all that sort of, you
 know, doesn't bother, I'm not, I'm not –

 Sorry, why? Why d'you think it matters, I don't
 think it…

He was hurt. He was a hurt person. He was a hurt Asian person Danny.

DANNY Okay. Alright.

Pause. Silence.

So what do you mean, 'if he didn't'?

LIAM What?

DANNY What do you mean 'if he didn't'?

LIAM Well, you know…with that amount of blood, what if he didn't get up and run off, d'you think he would've been alright?

DANNY What, if he didn't run off?

LIAM Yeah, would he be alright, d'you think

DANNY Did he run off?

LIAM Yeah, he did, but I'm saying if he didn't

DANNY What, run of?

LIAM Yeah.

DANNY Did he run off?

LIAM Yes, but

DANNY So what does it matter?

What does it matter what would've happened if he didn't run off?

LIAM It don't matter.

No, it doesn't matter, it –

Why? I mean…you know…

Beat.

It's hypothetical

HELEN Why are you being hypothetical?

 Silence.

 You're hiding something

LIAM No. I'm not, I'm not hiding

DANNY Are you, Liam? Are you hiding something?

LIAM No, I'm not, I'm not hiding –

 Pause. They are staring at him.

 I don't believe you're...fucking

 being like... For him? You don't even... I'm your brother, Helen, and Danny I thought we was, you don't even know what sort of person...

 Beat.

 Alright. Alright, he was, yeah, he was dodgy. Alright? He was a little fucking, a dodgy little, and that's not racist, but he was involved in all sorts. He was involved in –

 And, I'm not casting aspersions but all I'm saying is, right, alright, I'll tell you what, all I'm saying is you don't know what sort of person he is alright? I mean I don't either, fair enough, but you said, Helen, you said that he was probably, so it's me over him, I don't understand why you're taking the side of a

 dodgy...

 Pause.

HELEN Did he get up and run off, Liam?

LIAM Yes.

HELEN Then tell me.

 Beat.

LIAM Helen. I swear to you, on Mum and Dad's grave, he
 got up and ran off.

HELEN Okay. Right. Okay.

 Pause.

 So what is it you're hiding?

LIAM I'm not –

DANNY What aren't you telling us, Liam?

LIAM Don't start, Danny

DANNY Why are you saying he's dodgy?

LIAM He said it, okay? Happy? I didn't wanna say
 anything coz I didn't wanna say anything bad about
 him, but he told me, from what he said, piecing it
 together, fragments, he told me he was involved in,
 in stuff, indicated that he was involved in all sorts,
 and you don't know this world, Danny, you're a
 nice bloke and I like you but you don't know, not
 really, not when it gets, bad things, essentially,
 fighting and money and stuff like that. That's what
 he was involved in.

DANNY He told you this?

LIAM Yes.

DANNY He just volunteered this information?

LIAM He was hurt so, in a state of, and I was helping him

DANNY He just came out and told you this stuff?

LIAM Yes. Yeah, I'm saying…

 I pieced it together. Yes. From what he, ramblings
 and

DANNY When did he tell you this?

You said he was unconscious. You said he was unconscious, Liam.

Silence.

Liam?

LIAM What?

DANNY You said he was unconscious.

LIAM Yeah.

HELEN So when did he talk to you?

LIAM When he…

When he – hang on, hang on, okay – when he…

got up and ran off.

DANNY No.

LIAM No?

DANNY No. Not then. You said 'he got up, opened his eyes, stared at me through the blood and ran off.'

HELEN Were you lying?

LIAM No, no, of course not, you're confusing me now.

HELEN When did he speak, then?

LIAM Before.

HELEN Before what?

LIAM Before, he, before, when I found him, he was talking, like

DANNY But you said he was unconscious.

Beat.

LIAM Alright, look, stop it. You're confusing me, so just stop and…

and...

Alright.

Beat.

I found him. He was unconscious. He wakes up and started talking but then he passed out again, which is when I got blood all on me, because I held him in my arms, I didn't want him to bang his head and I put him down and then, a minute, and then he gets up and bolts off.

They stare at him.

And that's what happened. And I don't, I can't explain why I didn't say it was like that but I didn't. Alright? I didn't. Are you gonna believe me? That's all you've got to ask yourselves.

Are you

going

to believe me.

HELEN Liam –

LIAM No. No Liam, because you're my sister and I'm telling you something, you are my sister and I'm telling you something. So, Danny, so Helen... are you going to believe me? Yes or no?

Yes or no, are you going to believe me?

Beat. Suddenly a phone goes off.

Cheesy ring tone.

No-one moves.

Rings again.

Rings again.

Rings again.

LIAM takes it out of his pocket and turns it off.

Puts it back.

Silence.

He just come out at me.

He just, I was scared like and he, he just come out
at me like that and I didn't, I just lashed out. You
know, an impulse or, I think he thought he was
with his mates coz he's not a big lad, and there's no
way, I mean he's not gonna come out at me on his
own, I thought he thought he was, you know it's
an alley and he's come out at me, you know, to do
something quite bad, actually, to hurt, or rob, or,
just hurt, I was scared anyway coz it's dark that alley
and he just come out at me like a fucking, steam
train, Danny, you know. And I just turned and,
lashed, and, lashed out, and, caught him, and...
And he went down. And –

Beat.

I just kept hitting him. I mean I was crying, I was
crying but I was smacking him and pounding him
and he's on the floor, silent, not saying anything
like, and I couldn't work out why and I'm hitting
and hitting coz I'm shitted right up and I think I
might of, you know, started cutting –

Like, I had this blade?

Ian

He was showing me these little throwing knives
he's got, tiny, little heavy fat knives for throwing,
blade about an inch and a half long, but he keeps
them really sharp, like, and we're talking and he's
showing me other stuff and what have you and I
didn't know I still had it till I saw the blood coming
out of these cuts I'd made with it.

On this boy.

I was so angry, I was just 'why d'you come out at me, you little cunt' and he's not answering, he's not saying a word, which is making me angrier, and I stop and there's, just like blood, blood, and he's unconscious. That's, that's why he's not said anything. He's unconscious straight away, like, and I was, I kept, y know...

Beat.

I hugged him.

Pause.

Hels? Hels?

Danny?

Beat.

Hels?

THREE

LIAM alone, anxious.

Sitting. Staring.

Sniffs t-shirt.

HELEN enters.

Pause. They stare at each other.

LIAM You remember Brian,

Hels?

Brian Hargreaves? You remember him?

She doesn't answer.

You remember, at Shackleton, we was at, before we went to, we was, we hated that school, didn't we, we was always, you know, outside and. Year four they wouldn't let us be in the same class, would they. Would they, Hels, they wouldn't let us, not in the same class, I remember that Hilson, that cunt Hilson 'She's in year six, Liam. Helen has to be in with the older children' well fuck you, you beardy cunt, our parents have just been burnt to a crisp, so –

Beat.

Brian was alright, weren't he, you remember, Hels?

You remember him eating that stick? You remember that? A fucking stick, Hels, he ate a fucking stick! Big fucking stick off the floor. I mean who would eat a...

Beat.

Only one of them ever talked to me. The dirty gypo kid who eats sticks.

HELEN I remember.

 Pause.

LIAM Yeah.

 I was saying to Danny. I cried when he got beaten
 up.

 The violence. I just cried and cried and cried.

 Beat.

HELEN You mean when you beat him up.

 He looks at her.

 What do you mean 'when he *got* beaten up'?

 You beat him up. When *you* beat him up, Liam,
 when you beat him up, what do you mean –

 You smashed him to a pulp.

 You hit him with a brick.

 You broke his fingers, you pulled them back, you
 snapped –

 We had to leave school.

 I didn't hate that school, I loved that school. That
 was the best school we were at. We were never at a
 school like that again and we had to leave. I loved
 that school.

 Silence.

LIAM Danny alright?

 Beat.

HELEN Yes. Yeah, he's…alright.

LIAM Reckon he's a bit shook up.

HELEN No, he's fine.

LIAM Feel a bit funny in this shirt.

 Sniffs it again.

 I've fucked up haven't I?

HELEN Yes.

LIAM D'you ever wish they split us up?

 Beat. She stares at him.

 No, do you, though?

HELEN How can you say that?

LIAM You'd've got a good family if they'd split us up.

HELEN I've got a good family, we're a good family

LIAM There's something wrong with me.

HELEN You didn't mean it.

LIAM I'm scared, Helen. What am I?

HELEN You…you over-reacted, you just

LIAM Are you getting rid of it coz of me, Hels?

HELEN What?

LIAM Am I destroying you? Am I destroying you and
 Danny?

HELEN What are you talking about?

LIAM Am I a poison?

HELEN Liam

LIAM Am I a cancer, am I a dirty cancer

HELEN You are not a dirty cancer

LIAM Are you gonna tell the police?

HELEN No. No, god, Liam, of course I'm not –

LIAM Is Danny?

 No answer.

 I'll drink bleach before I go to prison.

 Beat.

HELEN You're not going to –

LIAM Tell him that, tell him I'll drink bleach before I go
 inside.

HELEN Don't manipulate me.

LIAM I love you. I love you so much. I love Shane. I
 love Danny. But I really love you. I really, really
 love you

 I'm fucking shitting it. I'm shaking again.

HELEN Sit down.

LIAM Okay.

 He sits.

 DANNY enters.

 Pause.

HELEN How is it?

DANNY yeah, it's fine, she's gonna keep him for another
 couple of hours.

HELEN Is he asleep?

DANNY It's half nine.

HELEN He should stay there.

DANNY She doesn't want him to stay there, she's got a thing
 in the morning.

HELEN But he's asleep…

 What did you say?

DANNY I just said that we needed a few hours.

HELEN That sounds like we've got a problem.

DANNY You're right, I should've said your brother turned up covered in blood following an incident with a knife.

You know what's she's like, she doesn't ask questions.

HELEN She's gonna have to wake him up now.

Beat.

Sorry.

Thank you for that, Danny. Thank you for doing that.

Pause.

LIAM How's your mum, Danny?

DANNY Yeah, she's okay.

LIAM She alright?

DANNY Yeah, yeah, she's fine.

LIAM Lovely woman. She's got, got a great sense of humour.

DANNY Has she?

LIAM I thought so.

DANNY Okay.

HELEN I was saying to Liam that we're going to sort this out.

DANNY Right. How?

LIAM Sorry, Danny.

DANNY How are we going to sort this out?

79

LIAM I'm really fucking sorry. I'm poison, I'm a cancer, a
 dirty cancer.

DANNY How are we going to sort this out?

HELEN Liam wants to ask you something.

DANNY Does he?

HELEN Yes.

DANNY Okay. What does he want to ask me?

LIAM Right.

 Danny, I am really sorry about all this, I mean
 you're, you, you're a nice bloke, a really decent, and
 you don't deserve this, you're not that sort of bloke
 and I really respect you and everything, you ask
 Helen, I tell my mates about you, I tell them what
 you're doing and how your work's going and…

 Beat.

 I was wondering

 what you were thinking of doing.

DANNY Doing?

LIAM Yeah. Like now.

DANNY What I'm thinking of doing?

LIAM Yeah, what are you gonna do? Are you gonna –

 Are you gonna call the police?

 Silence.

DANNY Liam, I'm not gonna call the police.

LIAM I love you two

HELEN See?

LIAM I love you two so much

80

HELEN See? I told you, I said

DANNY Of course I'm not gonna call the police

HELEN I told you, there's no need to worry, Danny's not, he's not gonna

Danny's not...

Danny is not going to –

> *Beat. Suddenly she hugs DANNY. Clings to him, suddenly desperate. DANNY returns the hug, love between them.*
>
> *Continues. LIAM doesn't know what to do. Goes to speak, doesn't. Waits... Waits...*
>
> *HELEN is still clinging to DANNY.*
>
> *They break. She pretends she has not been crying.*

HELEN Great.

LIAM Thank you, Danny.

HELEN That's...

No, I mean good.

LIAM Thank you so much.

DANNY It's alright, Liam.

HELEN Good. Great. No, that's good, that's...

LIAM Thank you so much, I feel like crying.

HELEN Don't cry.

LIAM No, I'm not gonna cry, but I feel like crying, that's what I feel like.

HELEN Great. Good. No, good, that's...

Good. Good.

Now we just need to sort out what we're going to say.

DANNY What?

 Beat.

 What do you mean?

HELEN Well, we need to sort out our story.

 If the police come here. And ask us.

 We have to say that Liam was here. With us.

 Beat.

DANNY We have to say that Liam was here with us?

HELEN Yes.

DANNY To the police?

HELEN Yes. Of course. Isn't that what we're talking about?

DANNY No.

HELEN No?

LIAM No, Danny?

HELEN Well, what are we talking about?

DANNY We're talking about not calling the police.

HELEN But if they ask?

DANNY Are they going to ask?

HELEN No, they're not gonna ask, they're never gonna ask, they're not gonna ask in a million years, but if they do ask…

 Then we'd have to say that Liam was here.
 All night.

 Beat.

 Danny?

DANNY Look, hang on

HELEN What?

DANNY You're saying lie?

HELEN Yes.

DANNY To the police?

HELEN Yes, to the police, of course to the police. Who else?

Danny?

DANNY What?

> *Beat.*

Doesn't that make us

accessories, or

HELEN Yes. Yes, it does.

DANNY Jesus.

HELEN Danny?

DANNY This is going too fast.

HELEN It has to go fast.

DANNY Why are you so calm?

HELEN I'm not calm.

DANNY Can we just slow, please, can we slow things
down and

HELEN No, we can't slow things down

DANNY think, because

HELEN we can't think we have to do.

DANNY I mean isn't that, what you're talking about, like
aiding and

HELEN Well, what do you think this is?

DANNY abetting, or – Not that, it's not that, this is not that.

HELEN What, not calling the police? Not calling the police is not that?

DANNY No, it's not the same as

HELEN Yes. It's the same as.

DANNY No, no, I don't think it's

HELEN Yes it is, fucking hell, Danny, wake up, this is not a game, this is your family, yes it is exactly the same, don't bury your head.

DANNY No, look, this is really serious, though.

I mean Christ, what, like in a court of law? is that what, are we saying

HELEN It's not gonna come to that

DANNY like under oath

HELEN It's not going to come to that, but yes. We are. That is exactly what we are saying.

DANNY I don't believe this. That is… serious, it's really, really serious.

HELEN Yes, it is. It is really, really serious. So can you please decide how much your family means to you.

 Pause.

DANNY No.

No, sorry, look…

fucking hell…

Look, I, no, no sorry, Liam, I mean Jesus Christ, this is one thing but that, you're talking about actually fabricating and maybe in a court of law and, Christ, sorry, no, I mean we have, this is our life. We have

84

a child. We have jobs, we have a house, we have a child. No. Sorry, no.

Pause.

HELEN Are you saying no?

DANNY Yes.

Beat. She goes to the phone, picks it up.

What are you doing?

HELEN I'm going to call the police. I'm going to tell them what's happened.

LIAM Hels?

DANNY Right, don't start being dramatic

HELEN I'm not being dramatic

DANNY because, look, don't start

HELEN I'm not being dramatic I'm just calling the police and turning my only brother in to the custody of the law

LIAM Er, Hels?

HELEN because we either do something or we don't, Danny. We do one thing or the other, we don't do half a thing, because that's doing nothing or doing the other thing or worse, there is no half thing, there's only one thing or another, there's doing or not doing, there's having a family or not having a family, there's us and them, protect or don't.

LIAM Hels?

HELEN No, Liam, because I'm not having this hanging over our heads like some fucking, every minute of every day waiting and knowing that I have in my family, in my home, every day, every night, looking at it

across the breakfast table, staring at it, watching it chewing.

LIAM Are you serious?

HELEN Yes. At least this way you tell them. You tell them, you admit, it'll be better for you. (*To DANNY.*) It's one thing or the other, Danny.

> *Beat.*

DANNY Is this what you did when I was in Miami?

> *She doesn't answer.*

I don't recognise this. I don't know what this is.

HELEN Are you going to help?

Are you going to help?

Are you going to –

Yes, this is what I did when you were in Miami because he was innocent, he's my brother and he was innocent.

You don't go out after dark anymore. You cross the street when you see a group of lads. You sit on the bottom deck of the bus and you stop talking when there are boys around. I need to know if you're a coward.

> *Beat.*

I hate living here, are we going to live here forever? I'm not frightened of doing things for my family. Liam would die for this family. He would die for us, he would lay down his life for Shane, he would willingly stop breathing to save you.

DANNY I'm… I am not frightened of doing things for my family either.

HELEN Are you going to help?

Are you going to help?

Are you going to –

DANNY Yeah.

 Beat.

HELEN Say yes then.

DANNY Yes.

HELEN Say yes, then.

DANNY Yes. I'm going to help.

And I'm not a fucking coward.

 Beat. She puts the phone down.

LIAM I love you two. I love you two.

I love you two so much.

I think he was one of the lads that did you, Danny.

 Beat.

There's no law out there. We're abandoned.

I love being here, coming here, you know that? I love being in this house, you two, Shane, walking in here is like walking in to, I dunno, perfume or like warm, a warm, I just love it actually. But going back out there is like walking into shit. Like walking into a soft wall of shit. Into fucking sewage, Danny. You imagine walking into sewage, Danny? well it's exactly like that, sometimes I wash the soles of my shoes, I scrub them with a nail brush.

I wanna be honest with you because you're so beautiful.

I followed him. I saw him ahead of me and I followed him. He was just walking ahead of me and I thought 'you little' and I followed him, close, just

to scare 'you fucking little' and he's frightened and
I'm thinking 'how'd you like it, you little fucking,
hurting people I care about?' in here lending
me your t-shirt, out the wash, but still, and I'm
screaming at him, you know, I've got hold of him,
been hitting him, hitting his face, and I'm screaming
into his face, you Paki, you Arab, you terrorist, you
fucking bin Laden, you beheading piece of, you
not-my-colour cunt, how dare you how dare you
threaten the people I –

Pause.

I dunno what come over me

I'm not like that. I'm not a racist. I dunno why

I dunno why...

I just wanted to scare him.

I dragged him into Ian's shed.

Tied him up. Hurt him. Left him there.

He's still there.

He's tied up. He's scared. There's a lot of blood.

Pause.

Brian Hargreaves started saying shit about you,
Hels. He said you was gonna leave me. He said
you'd asked them to separate us, begged them, he
said, said you'd told him, said you was gonna go off,
started saying all this shit about you, about my sister,
said you was gonna go off with some posh family,
said it was all sorted and you was gonna leave me.
He was saying shit about you, that's why...

I love you. I love both of you, all of you.

I love the fucking smell of you.

Silence.

HELEN Can...can he recognise you?

LIAM Yes.

HELEN He knows who you

LIAM Yes.

HELEN he knows who you are?

LIAM Yes. I told him.

HELEN Right.

LIAM I wanted him to think he was going to die.

HELEN Right.

LIAM I showed him my driving licence, I wanted him to think

HELEN So he knows who you are.

LIAM Yes.

HELEN Right. Right.

 Beat.

LIAM Helen?

HELEN I'm...

 I'm just trying to think Liam.

LIAM Okay.

HELEN Okay?

LIAM Sorry.

HELEN No, no, I just need to

LIAM Yeah, yeah, course.

HELEN Because this is, a bit, I just need to

LIAM Yeah.

HELEN We need, we should

 talk to him.

LIAM Right.

HELEN Explain…

 We should explain, er, have a

LIAM Talk to him?

HELEN a chat, talk, just to, er

LIAM He's scared.

HELEN Yeah, yeah, but if we talk to him

LIAM He's hurt bad.

HELEN Is he?

LIAM Yeah. I think he needs a hospital.

HELEN right.

 That was a bit, that was a bit stupid, Liam, showing
 him your

LIAM yeah I know

HELEN Because that's

LIAM Yeah

HELEN A bit

LIAM Yeah. Sorry.

HELEN No, no, but…

 Danny?

 Beat.

 Any…?

 Any ideas?

DANNY Any ideas?

HELEN Yeah, any…

 Beat.

 ideas?

DANNY Did you hear what he just said?

HELEN Yeah, but there's no point in

DANNY A chat?

HELEN We have to be

DANNY A chat?

HELEN practical, so don't start

DANNY a chat, did you just say chat, did you just suggest having a chat with a tied up Asian boy?

HELEN I know you're a bit shocked, but

DANNY Are you fucking mental?

HELEN you're surprised, this is, I'm surprised as well, and

DANNY You fucking attacked this boy?

HELEN angry, even

LIAM Angry?

DANNY You cut him with a knife, you tied him up, you tortured him?

HELEN Alright, but let's keep this

LIAM Are you angry, Helen?

DANNY What was going on, how could you do that, how could he do that?

HELEN Alright, what do you want to do?

LIAM Are you angry with me, Hels?

DANNY What do I want to do?

HELEN Yes. What do you want to do, what do you actually want to physically do, when you've finished flapping, when you've finished panicking, and screaming and screeching like a child, like a little fucking girl, Danny, when you've finished thinking and fantasising that we can do nothing what do you actually want to physically do?

DANNY Don't talk to me like that.

HELEN Do you agree we have to do something?

DANNY Do what?

HELEN Well, for example, we could do nothing, we could leave him there tied up and he could starve to death.

DANNY Why are you even saying that, that's stupid, that's –

HELEN Or Ian'll come home – yes, it is, it's stupid – and find him and call the police or do whatever he does when he comes home and finds tied up Asian boys in his shed, is that what you want to do?

DANNY Obviously not,

HELEN No. So we have to do something, we have to do something to help, to help, just stop thinking of yourself, Danny, and help.

DANNY Help who?

HELEN Help the boy, the boy, help the boy who's tied up

DANNY Did you hear what he said? He has to go to fucking hospital, he's –

HELEN Yes, exactly, he has to – right, yes, that's good, now you're thinking, that's, hospital, exactly.

 You're right, he has to go to hospital. We have to take him

DANNY Take him?

HELEN Yes, of course take him, he can't get there on his own, how else will he get there?

LIAM Sorry about all this, Danny

HELEN We can't call, that's out of the, that's an ambulance, that's the police, that's prison, we can't call

DANNY He's gonna call the police anyway

HELEN That's why I'm saying we have to talk to him.

DANNY Who, the boy?

HELEN Yes, the boy, we have to talk to him.

DANNY Talk to the boy?

HELEN Yes, we have to talk to the boy.

DANNY And what are we going to say to the boy?

HELEN We have to convince him not to say anything.

 We have to talk to him.

 We have to scare him.

 We have to frighten him. For his own good.

 Beat.

 What else can we do?

 We have to make sure that he's not going to say anything, we have to make him think that we're going to

 kill him if

DANNY What?

HELEN if he, yes, if he says anything, yes, yes, kill him, torture him, kill his family, whatever it takes to make him say it was a random attack.

DANNY And how are we going to do that?

HELEN You have to threaten him.

DANNY Me?

HELEN Well he's not going to be frightened of me, is he.

DANNY Me?

HELEN You can, no I mean, you wear something on your, over your head

LIAM Ian gave me a balaclava

HELEN a balaclava, you can wear a balaclava over your head and scare

DANNY I'm not wearing a

HELEN so he doesn't see you and so he thinks Liam's not just, not just an isolated, not just one person, not just on his own.

 Pause.

 Danny, I don't think, not for one, not for one minute that what he did, I don't agree with that, I'm shocked, and horrified and, but let's leave that for later, one side, and now, because he is my brother and he did this terrible, stupid thing to someone who…was he one of the boys who hurt Danny, Liam?

LIAM Yes.

HELEN Definitely?

LIAM Yes, definitely, he told me, he admitted it, he was one of those boys.

HELEN You're sure? He wasn't lying?

LIAM He wasn't lying. He was too scared to lie.

HELEN to someone who hurt you. He did it to protect you, in some way, and no matter how misguided that was he was trying to protect you and now you have to protect him because he loves you and I love you and now we have to do something.

We have to act to make it the best it can be for everyone.

Please.

Beat.

DANNY I

can't do that.

Pause.

HELEN What if it was Shane?

What if Shane came home covered in blood.

DANNY Shane is five.

HELEN He's not going to be five forever.

DANNY Don't talk about Shane coming home covered in –

HELEN What if Shane's twenty, or eighteen, or sixteen, or fourteen and he comes home covered in blood? What would you do?

Beat.

DANNY Why are you asking that?

HELEN What if it was Shane? Or

another child?

Beat.

DANNY What?

HELEN What if it was Shane, or…

or another child?

Pause.

DANNY What other child?

HELEN Another child.

DANNY We don't have another child.

HELEN No. We...could. We could have another child, if...

What if we had another child, and it was another child?

Beat.

DANNY What if we had another child?

HELEN Yes.

DANNY And that child came home covered in blood?

HELEN Yes.

DANNY The other child?

HELEN Yes.

Beat.

DANNY I thought... I thought you didn't want another child.

HELEN Did you?

DANNY Yes. I did.

HELEN Well.

Nothing's been

decided. Yet. Its all

it's all up for grabs.

DANNY Is it?

HELEN I'm asking for your help. I'm asking for you to make up your mind.

Pause.

DANNY What if we had another child and that child came home covered in blood?

HELEN Yes. What would you do?

DANNY What would I...?

Beat.

I would...

I would...

Pause. Looks at LIAM. At her.

HELEN Is this a family? Tell me. Tell me, is this a family?

Beat. Suddenly DANNY goes into the bedroom.

Silence.

LIAM Is he... is he gonna help?

Hels?

She doesn't answer him.

Is he? Is he, Hels.

HELEN Don't talk to me.

Beat.

you make me sick. You make me sick, you make me so fucking...

You piece of...

How could you, what kind of person, how could you bring in here...

Don't talk to me.

FOUR

Late at night. No-one here.

DANNY enters, coat on. Stares at the room as if he doesn't understand it.

Calms. Goes to sit, but doesn't. Decides to go into the kitchen, but HELEN enters. She has been in bed, but not asleep.

Pause.

HELEN Danny?

He opens his mouth to speak, but no words come out.

She stares at him. He goes to speak again, but instead goes into the kitchen. She doesn't know what to do. She waits.

After a moment he re-enters with a sandwich on a plate and a can of beer. Stops. Stares at her.

DANNY I haven't eaten.

HELEN No

DANNY I didn't have any

 dinner

HELEN Yeah, no, you should…

 He doesn't answer.

 Where's…

 Where's Liam?

DANNY He's alright.

HELEN Where is he?

DANNY He's alright, he's gone to the grave.

HELEN It's twenty past one.

DANNY Said he wanted to see Jeanie.

HELEN It's twenty past one.

DANNY Yes.

HELEN Are you okay?

He can't answer.

DANNY I haven't…

I didn't have any dinner, so…

Looks at the sandwich. Picks it up.

Puts it back down.

Can you hold my hand?

Beat. She goes to hug him.

No. Don't.

She stops, doesn't know what to do. Holds his hand. Pause.

He takes his hand away and uses it to drink the beer with. When he put the can down he doesn't take her hand again.

I went up the park. Went to look at the poster, the steam fair. There's a picture of –

it looks alright, it looks okay, actually –

there's a picture of a big steam engine and a family, blonde, all cheesy, but maybe that's the point. You know like circus posters, old ones, families and kids, people smiling, I couldn't tell whether it was a shit poster or whether that was supposed to be the point.

You know I kept looking at it and I thought

Beat.

is that the point, is that supposed to be…

Beat.

I stood there in the rain. For about an hour. I couldn't move.

She goes to hold his hand.

Don't touch me.

She stops.

He picks up the sandwich.

Can't eat. Puts it down.

HELEN What did you do?

DANNY I scared him.

HELEN Do you want to tell me?

DANNY No.

Pause.

Liam had tied him to this workbench, just this shitty shed at the end of Ian's garden, he tied him so that, I mean it was too small, the bench, for his legs. So they were hanging down, you know, bended at the knees and, and he had no

shoes on, and he'd tied him, like strapped him with rope and those bungee cord things and he had lots of, on his body, there were quite a lot of

cuts, on his body, there were lots and lots of –

He'd cut him.

Quite a lot.

Beat.

And his face was swollen. Like one side was like a balloon so that one eye was shut and the other was just staring like mad, a cow or something, just, you

know, there was a lot of blood actually, speckles and spots, some of it was dried and black, I mean he looked like

a monster or something, a swamp

thing

or something, not human and I kept thinking why's he got no shoes on.

Pause.

Oh yeah, and there were holes in him. Holes in his

flesh.

Where Liam had stabbed him with the knife.

It's this really small knife, like with this stubby little fat blade, but because it's small it doesn't go too far, it just breaks the skin, he'd been poking holes in him. Belly, arms, upper legs, lots and lots, actually.

Pause.

There was one hole in his cheek and I could see where the blade had snapped a tooth, you know the force, a molar, I think, not an incisor, so it must've been quite, the force must've been quite, like metal on tooth, snapping and I thought 'that's painful'.

There was this weird smell, I kept thinking 'what is that? What is that smell?' it was, you know, excrement, yes, because he'd, the fear had made him, and I didn't know that really happened and the shed was, you know, musty, but there was something else I couldn't –

HELEN Why are you telling me this?

DANNY What?

HELEN What are you…

What are you trying to…

DANNY Why am I telling you this?

Beat.

I screamed at him. I stood there in this balaclava and screamed into his face, 'tell me where you live, you paki. Not so fucking clever now, not so big without your fucking mates, you paki, you nasty paki, tell me where you live you nasty fucking paki.' I was like a fucking –

Beat.

because he wouldn't, he was scared we'd hurt his family so he wouldn't tell us, he just wouldn't. We got the gun, we broke into Ian's house and got the Luger and pointed it at him. I pointed it at him and told him I was going to fire it into his eye and when that didn't work I smashed the butt of it into his cheek. I did that, me. That's who I was.

HELEN And

and did he tell you?

DANNY What?

HELEN Did he

you know…

DANNY Yes. He told us. We made him tell us what it looked like so we could be sure it was the right place, and then Liam went to check on it.

HELEN Liam went?

DANNY You think I was going to leave him alone with Liam?

Beat.

So I just sat there. Staring at his feet. Listening to him crying. Just crying, you know. And in the end I thought 'I'll put his shoes on. At least I can put his shoes on', because I was, I was me again, I wasn't any more like and I felt, was feeling, and I picked up his shoes and I went to his feet.

It was petrol. The smell. Liam had taken his shoes off to pour petrol all over his feet, I think he'd tried to, I mean there were matches all over the floor, like from a book, but shitty ones, so, so he couldn't, they didn't work, the damp, so they wouldn't light, so that's…

You know.

Pause.

So that's, you know, that's good, that's a positive, at least…

HELEN And

And is it okay?

DANNY Is it okay?

HELEN Was it…was it the place?

Pause.

DANNY Yes. It was the place.

HELEN Right.

And what did you do with…?

DANNY We drove him into the woods, left him there, said if he told anyone we'd torch his house, lock up the doors and windows first so no-one would get out. He believed every word.

HELEN So it's okay? Danny?

DANNY Did you hear what I just said? Did you hear what I've just said?

HELEN Yeah, but –

DANNY He fucking tortured him. I fucking tortured him.

HELEN Well, you know…

DANNY What?

HELEN He went a bit

far, but

DANNY What?

HELEN Yeah, yeah, he went a bit

DANNY Did you just say 'he went a bit far'?

HELEN Because he, he thought, this person was not

Danny, this is not a good person.

Beat. He stares at her.

No, no, sorry, I know how that sounds and I do not mean that as an, but I mean Christ. This person, right, was not, he was someone, and that doesn't mean he should be hurt, of course not, but he was someone who hurts other people. He was not a good person.

DANNY What?

HELEN He was… Danny, he hurt, he was one of the people who hurt…you.

Beat.

DANNY Who?

HELEN The lad.

DANNY What lad?

HELEN The lad, the lad, I'm talking about the –

DANNY What lad, there is no lad.

 Beat.

HELEN What?

DANNY There is no lad.

HELEN Yes there is, the lad

DANNY The man.

HELEN who, you've just, you've just

DANNY He was a man, he was a grown man

HELEN been…

 Beat.

 What?

DANNY He was a grown man, thirty, thirty-five years old

HELEN I don't…

DANNY He was a man, just some fucking man, some Islamic
 man, that's all, on his way home. Some man with
 a beard, he wasn't a lad, he had nothing to do with
 anything, he had children, he was scared for his
 children, he was at least thirty-five.

 Pause.

HELEN What?

DANNY I hurt him, Helen. I had a balaclava on.

HELEN He was…

DANNY I've always wondered whether I'd be good at that
 sort of thing. Enjoy, or…something, you know,
 whether you… And now I…

 I feel like I'm rotting.

HELEN He was a man?

DANNY Yes.

HELEN Not a lad?

DANNY No, no, not a fucking lad.

HELEN Just a man?

DANNY Just a man, just a man on his way home

HELEN An Islamic man?

DANNY Just an Islamic man on his way home to his wife and his children.

HELEN Oh.

DANNY Yes.

Yes. Oh.

Front door slams, really loud.

Moment later LIAM enters.

LIAM Shit, sorry, Hels. Sorry Danny, fuck. Sorry, I fucking let go and that door, I keep forgetting, I just, it slams, it…bit strong that door bit fucking –

Looks at them.

Pause.

Alright, Danny?

No answer.

Hels?

No answer.

Yeah. Yeah, fair enough, that's…

Sorry about that. Sorry about…well, I'm sorry. This is all wrong, I know it is and, and look I wanna say I'm sorry. Sorry, Hels.

Sorry, Danny.

Sorry, Hels.

They say nothing.

Okay, okay, alright. Fair enough, I'm not saying anything different, and I have to say that I don't feel good about bringing you, not at all, I do not feel good at all about, you know, you've got this world, this beautiful world and it's like dragging a dead cat into it and leaving it on your sofa, on your beautiful sofa that you got from John Lewis and saying 'look, look a dead fucking cat.'

But there are dead cats in the world, Danny, there are dead cats, Hels.

Beat.

You're pissed off at me, aren't you.

Okay. I deserve that. Alright, I deserve that, that is fair enough, but I'm gonna make it up to you. Hels? I'm going to make it up to you. I am going to make it up to you, Danny, I'm gonna make amends. There. That's a fucking contract. That is a fucking promise.

Pause.

HELEN He was a man?

LIAM Well

HELEN Was he or wasn't he?

LIAM Well, yeah, but

HELEN He was?

LIAM he looked, I mean it was dark and...

Beat.

107

Yes. He was.

HELEN Why.

LIAM I

dunno. I dunno, Hels, I just…

I dunno.

Pause.

HELEN You don't know.

LIAM No.

HELEN Right.

DANNY I don't want him in my house.

LIAM Can I just say something? Can I just say one thing? I look at you, Danny, I look at you and I want, not to be like you, not to be you, but yes, in some way actually to be you, to actually be in some way a fucking part of you, but I want it to be me, I want you to be me. And if you and Hels weren't, I would still, and I look at you and I say 'Yeah, he's had all the breaks, so what? He's got a family, so what, he knows what he's doing, so what? He's got a good job and mates that he gets on with and a beautiful wife, he's clever and he's had all the advantages in life and that may well be why he has all those things while another human being, a different human being gets to have shit thrown at them for years and then to top it all becomes a shit human being in the process, so what: he fucking deserves everything.' You deserve everything. And I say good luck to you because you are everything that man in this 21st century should be.

And I stand here, in your shirt, in your dirty fucking old t-shirt that you pulled out of the wash to give me and I feel privileged to wear it. I feel privileged

to stand in your stale sweat. And I see someone like you and I can't help thinking that you should never have experienced this, that your blissful ignorance should be protected above all else, that I should lay down my life to keep you in that state, but part of me, Danny, and this is the part I hate, this is the bad part, the dirty part, the part that I'd like to cut out with a knife, part of me, and I'm not saying I like that part, I'm saying I hate that part, but part of me thinks you should be dragged down of that fucking pedestal and be forced face down into the mud so you can eat the same shit and rotting flesh I've been eating, so that it gets in your mouth and up your nose and that you choke on it. And

I saw you tonight, Danny. I saw you…

> *Beat.*

We're abandoned. There's nothing out there. It's like they've all been beamed up to another planet and just left us with the monsters.

HELEN Get out.

LIAM Right, Hels

HELEN The monsters? You're the monster, get out.

LIAM You're angry, okay, fair enough, but don't

say something you're gonna regret.

> *Pause.*

HELEN Regret?

Don't say something I'm gonna regret?

LIAM You're angry now, and fair enough, I'm not, not for a second saying otherwise, but all I'm saying Hels, is, I can be pushed as well, I have limits, there are limits and all I'm saying, Danny, is it's been a long and traumatic, so let's not –

HELEN I was going to go with that family.

 Beat.

 Brian was right. I told him, because I was so
 excited. I had to tell someone.

 Beat.

LIAM What...

 what are you...?

HELEN His name was John, hers was Jackie, John and
 Jackie, they lived in a lovely place, I remember,
 green and I remember the road was...lovely.

LIAM No, I don't...you didn't, this is, this is...

HELEN They had a boy a little older than me, Adam, he
 had a tree house in the garden, but it wasn't in a
 tree it was on the ground, they'd built it for him
 on the ground because he didn't like heights but it
 was all his, they never went in there, they respected
 his space.

 Beat.

LIAM Right, don't say...

 Okay, okay, fair enough, but don't say hurtful,
 Hels, things, Hels, because that's not gonna get us,
 where's that gonna get –

HELEN She had a job, I don't remember what it was, but
 I remember she had it because mum never had a
 job, she just sat around smoking, he was a doctor
 and I thought that was amazing, that someone's dad
 could really be a doctor. And his face was lovely.
 He had a lovely face, I don't remember his face but
 it was lovely and their house was clean, not like our
 house, our house was filthy, I played a game with
 them, a board-game, I don't remember what it was,
 but we all sat down and played it together and I

was amazed, all of us, just sitting there playing this game, John and Jackie as well.

Beat.

Adam kept showing me things. And telling me things. Things I didn't know, I didn't know them and he could tell I didn't know them but he never laughed at me, never once, he never once laughed at me for not knowing. He just told me things, all these things, and he showed me his rabbit. He let me hold her. She was soft and warm and I held her for ages, for ages, I just held her for ages, and I started crying, I was holding his rabbit and crying and he didn't say anything, he just let me, he just let me hold her and cry for ages and ages and ages and ages.

LIAM Right. Okay.

No you didn't, you're just

Beat.

I don't care, I'm not… Fucking hell, I mean, I'm not –

Anyway, that's not true, none of that is true, I mean none of that is –

What? d'you think I'm stupid? D'you think I'm fucking stupid, Hels? I'm not stupid. I'm not fucking stupid, Hels, I know what you're –

Beat.

I know what you're doing, I know, fucking stupid is it? fucking, fucking, none of that, not one word is true and you didn't, because you…

Beat. Suddenly takes a step towards her, so full of rage he doesn't know what to do with it. Wants to kill her,

smash her face in, pound her to death. Stops. Masters it.
Steps back from her.

She has not flinched. He has calmed himself.

You're angry. Yeah, and fair enough, you're, and so you're

being a bit, you are being a bit...

Okay, I'll take that, fair enough

HELEN I loved them.

LIAM deserved that, fair enough, can't argue with

HELEN I begged them to let me go with them. But after you attacked Brian we got moved away. I begged and begged and begged.

LIAM I forgive you. I love you and I forgive you.

HELEN I don't want you to forgive me.

LIAM Well I do. I forgive you. I forgive you so much.

The door swings open.

SHANE stands there, bleary eyed.

Beat. For a moment no-one knows what to do.

Shanie!

SHANE almost sleep-walks into the room, going straight to LIAM, arms around him, lying into him, half asleep. LIAM, genuinely moved.

Ahh, look. Did I wake you up, Shay? Sorry about that, mate, that was the door, that flipping door again.

HELEN What are you doing up?

LIAM Ah, it's my fault, Hels, I woke him up.

HELEN You should be in bed.

LIAM You alright, Shay? You have a good time at your
 Gran's?

 SHANE nods.

 She's a lovely woman in't she. She give you ice
 cream?

 SHANE nods again.

 Did she! She's a cheeky monkey, in't she? Tell
 you what mate, you should get to bed, coz you're
 knackered.

 SHANE hugs harder into LIAM.

 Ahh, look. How about this; you go to bed and then
 on Saturday, if you ask your mum and dad very
 nicely and if you're a good boy, I'll take you up the
 park, would you like that? There's a steam fair up
 the park, it's all like engines and tractors and –

HELEN Shane, come here.

 Beat.

LIAM I'm just telling him about –

HELEN He's not going.

 Shane come here, now.

 SHANE does as he's told.

 LIAM is shocked.

 It's late.

 Beat. LIAM gets up.

LIAM Yeah. Yeah, fair enough. I'll just.

DANNY Tell him to leave the key.

LIAM Look, Danny, I'm –

HELEN Leave the key.

LIAM What?

 Pause.

 Hels…?

HELEN Leave the key.

 Pause.

LIAM Hels? Please don't tell me to leave the key.

HELEN Leave. The key.

 Beat. LIAM takes the key out of his pocket.

 Puts it on the table.

 Doesn't know what to do.

 Yeah, well, I'm a bit tired and…

 Bye Shane, I'm…

 SHANE is too sleepy to answer, hugged face into mum.

 Yeah.

 LIAM goes. SHANE waves at him, not looking up, but LIAM doesn't see it.

 A moment, then the front door slams.

 They sit. Together. Silence. SHANE is sleeping.

HELEN Are you alright?

 No answer.

 I could make something to eat. Do you want something to eat?

DANNY I can't eat.

 Silence, apart from SHANE's breathing.

 What do we do now?

HELEN I don't know.

 Carry on.

DANNY How?

HELEN I don't know.

 We find things to do and then we do them.

DANNY What things?

HELEN Things.

 Good things.

DANNY Good things?

HELEN Yes.

 We could…

 We could help people.

DANNY Could we?

HELEN Yes. We could help people.

DANNY What people?

HELEN People who

 people who need help.

DANNY Right.

HELEN We could do that, that'd be a reason to…

 you know, dedicate our lives to…

 or something.

DANNY Right.

 Long pause.

HELEN I've been thinking. While you were out. I was here
 and I was thinking about lots of things and I got to
 thinking about you and me

 and I think, I think I've been a bit...harsh

DANNY Harsh?

HELEN on us, yes, harsh.

DANNY I see.

HELEN I think I've been judging us and us together a bit
 harshly and judging us by some standard that isn't
 a real, for whatever reason, and maybe it's time to
 grow up and use real standards and, and, and

DANNY Right.

HELEN and accept. And once I'd thought like that, once I
 thought the word accept, I began to feel good.

DANNY Did you?

HELEN Yes. I began to feel good about our life, and about
 our family and about what we are and who we
 are and what we've made together, given the
 circumstances, given the hurdles and hiccups and I
 know this is going to sound mad, because of tonight
 and everything that's –

 I know this is going to sound mad, you're gonna
 think I'm, but I began to feel warm. Here.

DANNY Where?

HELEN Here.

 She puts his hand on her stomach.

 And I'm sitting there thinking this, all this is running
 through my mind and suddenly I'm

 and this really is going to sound, you're gonna
 think I've lost the, but I'm gonna say it anyway

because it's what happened but you're gonna think I'm totally, but because of this feeling and these thoughts I...

Alright; I began to laugh.

DANNY Did you?

HELEN See? I told you. You think I'm mad.

DANNY I don't think you're mad.

HELEN Don't you?

DANNY No.

HELEN You sure?

DANNY You laughed?

HELEN Yes.

DANNY You just sat here on you own

HELEN Yes.

DANNY laughing?

HELEN Yes. I just sat here on my own laughing, I just started laughing. I just started laughing, and that's terrible because of tonight and what you had to, god, fuck, I know, and I felt such

guilt, because I was, but then I thought, you know this is positive and positive things, I shouldn't feel guilt, I shouldn't

but I couldn't help it I just laughed because, I felt this feeling and I knew that this feeling was you and me.

Us.

You and me made me so happy that I laughed.

Pause.

I want this child.

DANNY Do you?

HELEN Yes. I do.

DANNY Really?

HELEN Yes. Really.

DANNY Right. Right.

Pause.

You

want that child?

HELEN Yes.

DANNY You want that child with me?

HELEN Yes.

DANNY My child?

HELEN Yes. I want your child. Our child.

DANNY Right.

Pause.

No.

Beat.

HELEN What?

DANNY I don't want it.

HELEN You don't…

DANNY I don't want that child.

I don't want that child.

Get rid of it.

HELEN I…

DANNY Get rid of it. Take it out. Take that child out. I want you to get rid of that child.

He begins to pull his hand away, but she won't let him.

HELEN I...don't want to get rid of it.

DANNY You have to.

HELEN No.

DANNY You do.

HELEN No.

DANNY Yes.

HELEN No.

DANNY Yes.

HELEN No.

He continues to try to pull it away. But she continues to hold it there. This continues.

END